太極功夫扇
Taiji Kungfu Fan

李德印　方彌壽　编著

Li Deyin　Fang Mishou　Author

優酷學習太極扇　　　　YouTube 學習太極扇

再 版 前 言

我出生在一个武术世家，自幼在爷爷的武馆长大。爷爷是东北三省太极拳的开拓者，他要求很严，规定李家男孩必须"白日学文，夜晚习武"。1961 年，我从中国人民大学毕业，留校任教。从一名年青武术助教，到人民大学体育部教授、主任，在大学校园教拳育人，度过了四十个春秋。

妻子方弥寿是我中学的学妹。她中年多病，在我的鼓励下，参加了太极健身锻炼，获益良多，成了一名太极拳铁粉。我们现在已经是和将要是 80 后的耄耋老人。打拳舞扇，健身乐群，成了我们退休生活的每日必修课。本世纪初，北京申办奥运会期间，我们应北京市老龄人体育协会邀请，创编了《太极功夫扇》，受到广大爱好者欢迎。两千多名老龄朋友汇聚在天安门南广场举行了首次表演，成了支持北京申奥活动的新亮点。2009 年 8 月 8 日全民健身日，北京近四万人在国家体育场举行了24 式太极拳和太极功夫扇大合练，创造了吉尼斯新世界纪录。

2020 年春，空前的新冠疫情席卷全球，夺去了数十万人生命，使人们更加认清了增强体质，提高免疫力，加强自身抗毒防疫的重要性。在非常时期，香港国际武术总会主席，中国太极拳著名传承人冷先锋先生，大力倡导武术健身，力邀我再版《太极功夫扇》，为港、澳、台同胞健身抗疫助力加油，我十分感动和感谢。为此，不惴疏浅，呈献付梓，敬希读者喜欢，敬请方家指正。

我衷心祝福各位读者和广大港澳台同胞，积极参加太极健身运动。

拳舞太极道，人享康乐福，阖家平安吉祥。

作者 李德印

Preface to the reprint

I was born into a martial arts family, and grew up in my grandfather's martial arts school. My grandfather was a pioneer of taijiquan in the three provinces of northeast China. He was very strict, stipulating that Li family boys must "study literature by day and martial arts at night." In 1961, I graduated from the Chinese People's University and stayed on as a lecturer. I spent 40 years teaching martial arts and educating university students, progressing from a young martial art teaching assistant to professor and director of the Sports Department of the People's University.

I met my wife Fang Mishou as a middle school student. She became very sick in her 40's. With my encouragement, she took up taijiquan exercises and benefited greatly. She became an ardent fan of taijiquan. We are now elderly people, both in our 80s. Practicing Taijiquan and Taijishan (Taiji fan) have become enjoyable daily activities in our retirement. At the beginning of this century, during Beijing's bid to host the Olympics, we were invited by the Beijing Seniors Sports Association to create the "Taiji Kungfu Fan" routine, which was instantly welcomed by enthusiasts. To support Beijing's Olympic bid, more than 2,000 senior enthusiasts participated in the "Taiji Kungfu Fan" routine's first public performance at Tiananmen's Square. The incredible performance was one of the most impressive cultural performances which supported of Beijing's Olympic bid. The momentum of the "Taiji Kungfu Fan" routine continued and on 8th August 2009, China's National Fitness Day, nearly 40,000 people in Beijing gathered and held a mass performance of 24-form Taiji and Taiji Kungfu Fan at the National Stadium, setting a new Guinness World Record.

In the spring of 2020, an unprecedented new coronavirus pandemic swept the world, claiming hundreds of thousands of lives, making people more aware of the importance of strengthening their physical fitness, improving immunity, and protecting their health from viruses. In these extraordinary times, Mr. Leng Xianfeng, chairman of the Hong Kong International Wushu Federation, a famous inheritor of Chinese Taijiquan, and a very firm advocate for martial arts fitness and invited me to republish this book on the "Taiji Kungfu Fan" to help our compatriots in Hong Kong, Macao and Taiwan fight the pandemic. I was very moved and grateful. I therefore respectfully offer this book hoping that readers enjoy it and seek their feedback.

Through the art of Taiji, may people enjoy well-being, peace and good fortune.

Li Deyin (author)

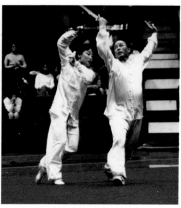

作者夫妇太极拳对练（2006 年） 与堂妹李德芳表演武当对剑（1993 年）

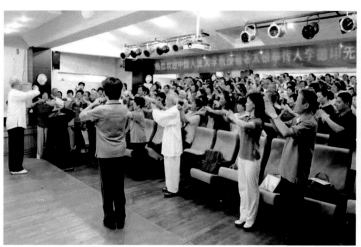

讲课结束师生互致抱拳礼 指导中国优秀运动员高佳敏（1990 年）

接受英国武术协会的颁奖 拜访香港武术联合会会长霍震寰

中国人民大学李德印太极拳教学展演会（2017 年）

指导深圳市太极拳爱好者

指挥北京亚运会开幕式太极拳表演队伍入场

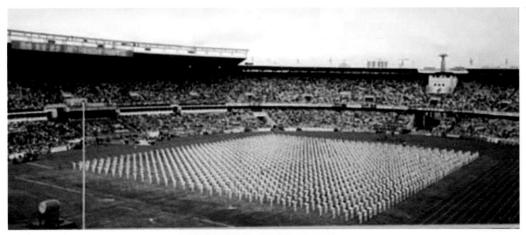

北京亚运会开幕式太极拳表演（1990 年）

在美国的太极功夫扇教学

赴台湾太极拳总会教学

接待来访的日本首相铃木善幸（1982年）

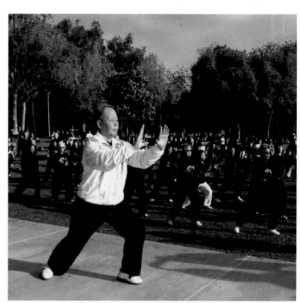

在美国硅谷带领太极拳爱好者晨练

首届世界太極拳交流大會（香港）

应邀访问印度尼西亚

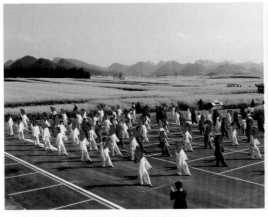

云南罗平县太极功夫扇训练

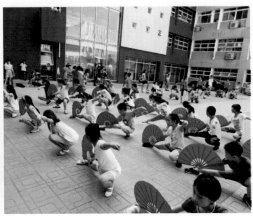

北京市小学生的课余练习

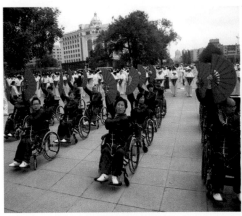

哈尔滨残障人士表演

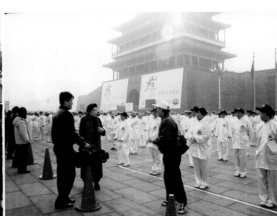

太极功夫扇首次在北京亮相表演

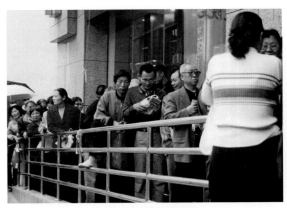

等待购书签名的热情读者

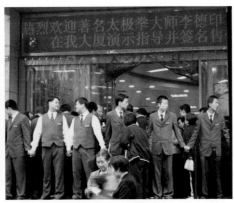

在郑州图书大厦签名售书

目　　錄

DIRECTORY

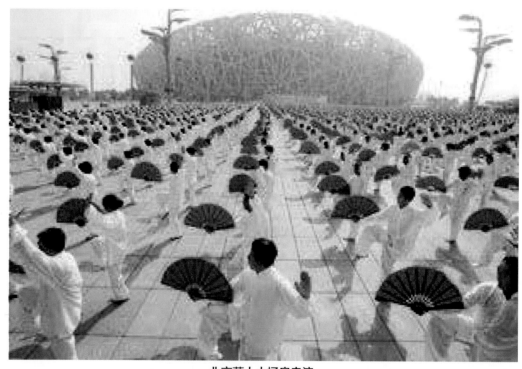

北京萬人太極扇表演

太極功夫扇内容介紹

"太极功夫扇"是北京市老龄体协为支持北京市申办 2008 年奥运会，大力开展全民健身活动，于新世纪初组织创编的太极拳新套路。主编人是中华武林百杰，国际级武术裁判，中国人民大学李德印教授。

这套太极扇的创编，丰富了老龄朋友健身活动内容，受到了太极拳爱好者热烈欢迎。2001 年 2 月 18 日，在"北京国际公路接力赛"开幕式上，来自北京市八个区县的二千零八名老龄朋友，聚集在天安门南广场作了《太极功夫扇》表演。他们伴随着《中国功夫》歌曲，精神抖擞，意高气扬，挥拳舞扇，展现了当代老龄人的精神风貌，构成了北京市申奥活动的新亮点。

这套太极扇的"新"不只表现在一项新编武术套路，更可贵的是在弘扬太极拳传统的基础上，做出了有益的新探索、新创造。使古老的太极拳绽放出新的光彩，令人耳目一新。突出表现在：

1、将太极拳与其它武术项目以及京剧、舞蹈动作巧妙结合，为太极拳运动注入了新活力。

2、将人们消暑纳凉、舞台道具的摺扇，纳入太极拳运动，为太极拳器械增加了新品种。

3、将太极拳与现代歌曲相结合，出现了载歌载"武"的新形式。

《太极功夫扇》全套分为六段，每段八个动作，加上起势、收势和两个过门，共计五十二个动作。

第一段动作以太极拳、太极剑的技法和风格为主线，表现了扇子的抱、分、开、合、刺、撩、劈、压等技法，结合《中国功夫》歌曲每分钟 66 拍的慢板，每动八拍，动作柔缓自然，轻灵稳定。

第二、四段动作，以长拳、查拳等快速有力的武术技巧和风格为主线，表现了削、推、按、藏、亮、挽花等扇法和戳脚、震脚腿法，结合歌曲每分钟 104 拍快板，每动四拍，动作明快，动静分明。

第三、五段动作以南拳、陈式太极拳的刚健、发力、发声动作和京剧、舞蹈的造型亮相为主线，表现了扇子的挑、贯、云、劈、拨、拍等方法以及蹬脚、举腿、砸拳、顶肘、纵跳等武术元素。结合歌曲念板，动作健美勇猛，发声助力，气势雄壮。三、五段以后各有一个过门动作，分别以抱扇、行步，一动一静的不同方式承前启后，巧妙连接。

第六段以杨式、吴式太极拳 的技巧和风格作为结尾，表现了掤、捋、挤、穿、架、戳、背等扇法，在柔缓悠长，连贯圆活的动作中平稳收势。

这套太极扇的造型优美，结构新颖，动作有刚有柔，节奏快慢相间，同时伴以发力发声，歌武结合，不仅提高了锻炼的健身性，同时增加了动作的趣味性和观赏性，使老龄朋友的太极健身活动增添了朝气蓬勃，多姿多采的气氛。

这套太极扇的创编，内容尽量选取群众熟悉的动作，场地不超过 3×2 米，力求方便群众学练和集体演练。有一定太极拳基础的朋友，一般经过两次培训，用 4~6 小时的时间即可掌握。

Brief Introduction to Taiji Kungfu Fan

"Tai Chi Kung Fu Fan" is a new Taiji routine created at the beginning of the new century by the Beijing Sports Association. The main author, Professor Li Deyin, of the Chinese People's University, is an outstanding figure in Chinese martial arts and an international martial arts referee. The "Tai Chi Kung Fu Fan" form was part of a vigorous national fitness drive, and was created for the elderly to support Beijing's bid to host the 2008 Olympic Games.

The creation of this Taiji fan routine has enriched the variety of fitness activities for the elderly and has been warmly welcomed by Taiji fans worldwide. On 18th February 2001, at the opening ceremony of the "Beijing International Highway Relay Race", two thousand and eight elderly people from eight districts of Beijing gathered in Tiananmen Square to perform the "Taiji Kungfu Fan" for the very first time publicly. Accompanied by the song "Chinese Kung Fu", the 2,008 performed with energy and high spirits as they brandished fists and fans, demonstrating the spirit of contemporary elderly people in China and creating a real highlight amongst the various demonstrations that supported Beijing's successful Olympic bid.

The "newness" of this Taiji fan routine manifests not only in a new martial arts routine, but more importantly it has created a path for beneficial new explorations and new creations in carrying forward the tradition of Taiji. By the creation of new forms makes ancient Taijiquan bloom with a refreshing new brilliance. In particular the "Tai Chi Kung Fu Fan":

1. Displays the ingenious combination of Taijiquan with other martial arts, Beijing opera and dance movements has injected new vitality into the Taijiquan movements.

2. Incorporates a typical folding fan as used by people to cool themselves, or as a stage prop, as a new item of Taiji equipment.

3. Combines Taijiquan with modern songs, a new form of performing martial arts has emerged, mixing martial and cultural tradition with contemporary creativity.

The complete "Taiji Kungfu Fan" routine is divided into six sections, each with eight movements, plus opening, closing and two transition movements, for a total of fifty-two movements.

The movements of the first section are based on the techniques and styles of Taijiquan and Taiji sword, demonstrating such techniques with the fan as encircle, separate, open, close, thrust, lift up, chop, press. Combined with the song "Chinese Kung Fu" at 66 beats per minute (adagio), eight beats per movement, the movements are reflective of Taiji; gentle and natural, smooth and steady.

The movements of the second and fourth section are based on the fast and powerful martial arts skills and styles of Chang Quan(Fist) and Cha Quan (Fist), demonstrating techniques with the fan such as slice, push, press down, conceal, flash, wrist circle, as well as kicking and stamping with the feet. Combined with the song at 104 beats per minute (allegro), four beats per movement, the movements reflect powerful the martial elements of Kung Fu and are quick, strong and dynamic.

The third and fifth movements are based on the vigour, force, and vocalizations of Nan Quan (Southern Fist) and Chen-style Taijiquan, as well as the appearance of Peking opera and dance styles, demonstrating techniques with the fan such as pluck, thread, cloud circle, chop, block, pat, and such martial arts elements as kick, leg raise, punch, elbow strike, and jump. Combined with the beat of the song, the movements are strong and powerful, imposing and majestic whilst emphasized with vocalizations. After the third and fifth sections, there is a 'pass through doorway' movement, cleverly connecting the preceding and following sections with different techniques of holding the fan in both stillness and motion by walking.

The sixth and final section is based on the skills and styles of Yang-style and Wu-style Taijiquan. This section demonstrates techniques such as ward-off, pull back, press, pierce, lift up, stab and back folding, bringing the form to a graceful close with soft, smooth, coherent and rounded movements.

This Taiji fan routine is beautiful in shape and innovative in structure. The movements combine power and softness, with fast and slow rhythms. At the same time, the combination of a popular song, accompanied by energetic vocalizations with martial movements not only raises the fitness level of participants, but also increases the fun and appreciation of the movements, adding an ingenious and colourful atmosphere to the Taiji fitness activities of the elderly.

This Taiji fan routine has been created as far as possible from movements familiar to the majority of Taiji practitioners, and requires a space no more than 3 x 2 metres. The familairty and space required assists in facilitating group learning, practice and performance. For those with a foundation in Taiji, it can be typically learnt after two training sessions, in 4-6 hours.

太極功夫扇動作名稱
Action name of Taiji KungFu Fan

第一段 First section

（一）起　势　（开 步 抱 扇）
qǐ　shì　（kāi bù bào shàn）

(1) Opening form (open step encircle with fan)

（二）斜 飞 势　（侧 弓 举 扇）
xié fēi shì　（cè gōng jǔ shàn）

(2) Oblique flying (side bow stance raise fan)

（三）白 鹤 亮 翅　（虚 步 亮 扇）
bái hè liàng chì　（xū bù liàng shàn）

(3) White crane flashes its wings (empty stance flash fan)

（四）黄　蜂 入 洞　（进 步 刺 扇）
huáng fēng rù dòng　（jìn bù cì shàn）

(4) Yellow bee enters a cave (step forward and thrust fan)

（五）哪 吒 探 海　（转 身 下 刺）
nǎ zhà tàn hǎi　（zhuǎn shēn xià cì）

(5) Deity Ne Zha probes the sea (turn body thrust downwards)

（六）金 鸡 独 立　（独 立 撩 扇）
jīn jī dú lì　（dú lì liáo shàn）

(6) Golden rooster stands on one leg (stand on one leg raise fan)

（七）力 劈 华 山　（翻 身 劈 扇）
lì pī huá shān　（fān shēn pī shàn）

(7) Split Mountain Hua (turn over chop fan)

（八）灵 猫 捕 蝶　（翻 身 抡 压）
líng māo bǔ dié　（fān shēn lún yā）

(8) Nimble cat catches butterfly (turn over, swing and press)

（九）坐 马 观 花　（马 步 击 扇）
zuò mǎ guān huā　（mǎ bù jī shàn）

(9) Sitting on a horse gazing at flowers (horse stance flash fan)

第二段 Second section

（十）野 马 分 鬃　（弓 步 削 扇）
yě mǎ fèn zōng　（gōng bù xuē shàn）

(10) Part the wild horse's mane (bow stance slice fan)

（十一）雏 燕 凌 空　（并 步 亮 扇）
chú yàn líng kōng　（bìng bù liàng shàn）

(11) Young swallows soar in the sky (closed stance flash fan)

（十二）黄 峰 入 洞　（进 步 刺 扇）
huáng fēng rù dòng　（jìn bù cì shàn）

(12) Yellow bee enters a cave (step forward and thrust fan)

（十三）猛 虎 扑 食　（震 脚 推 扇）
měng hǔ pū shí　（zhèn jiǎo tuī shàn）

(13) Fierce tiger pounces on prey (thud foot push fan)

（十四）螳 螂 捕 蝉　（戳 脚 撩 扇）
táng láng bǔ chán　（chuō jiǎo liáo shàn）

(14) Praying mantis catching cicadas (heel kick flick fan inward)

（十五）勒 马 回 头　（盖 步 按 扇）
lè mǎ huí tóu　（gài bù àn shàn）

(15) Rein in horse to look back (crossover stance press fan)

（十六）鹞 子 翻 身　（退 步 藏 扇）
yào zǐ fān shēn　（tuì bù cáng shàn）

(16) Harrier turns over (step back, coil and hide fan)

（十七）坐 马 观 花　（马 步 击 扇）
zuò mǎ guān huā　（mǎ bù jī shàn）

(17) Sitting on a horse looking at flowers (horse stance flash fan)

第三段 Third section

jǔ dǐng tuī shān　(mǎ bù tuī shàn)
(十八) 举 鼎 推 山　(马 步 推 扇)

(18) Lift cauldron push mountain (horse stance push fan)

shén lóng huí shǒu　(zhuǎn shēn zhā shàn)
(十九) 神 龙 回 首　(转 身 扎 扇)

(19) Spirit dragon turns its head (Turn body thrust fan)

huī biān cè mǎ　(chā bù fǎn liáo)
(二十) 挥 鞭 策 马　(叉 步 反 撩)

(20) Brandish whip to urge on horse (cross step reverse flick)

lì mǎ yáng biān　(diǎn bù tiāo shàn)
(二十一) 立 马 扬 鞭　(点 步 挑 扇)

(21) Rearing horse raise whip (point step pluck fan)

huái zhōng bào yuè　(xiē bù bào shàn)
(二十二) 怀 中 抱 月　(歇 步 抱 扇)

(22) Embrace the moon (rest stance embrace fan)

yíng fēng liáo yī　(bìng bù guàn shàn)
(二十三) 迎 风 撩 衣　(并 步 贯 扇)

(23) Facing wind lifts robes (close stance round strike fan)

fān huā wǔ xiù　(yún shǒu pī shàn)
(二十四) 翻 花 舞 袖　(云 手 劈 扇)

(24) Turn over flowers to brandish sleeves (cloud hands chop fan)

bà wáng yáng qí　(xiē bù liàng shàn)
(二十五) 霸 王 扬 旗　(歇 步 亮 扇)

(25) Overlord raises flag (rest stance flash fan)

bào shàn guò mén　(kāi bù bào shàn)
(二十六) 抱 扇 过 门　(开 步 抱 扇)

(26) Embrace fan pass through doorway (open step embrace fan)

第四段 Fourth section

yě mǎ fèn zōng　(gōng bù xuē shàn)
(二十七) 野马分鬃 (弓步削扇)

(27) Part the wild horse's mane (bow stance slice fan)

chú yàn líng kōng　(bìng bù liàng shàn)
(二十八) 雏燕凌空 (并步亮扇)

(28) Young swallows soar in the sky (closed stance flash fan)

huáng fēng rù dòng　(jìn bù cì shàn)
(二十九) 黄峰入洞 (进步刺扇)

(29) Yellow bee enters a cave (step forward and thrust fan)

měng hǔ pū shí　(zhèn jiǎo tuī shàn)
(三十) 猛虎扑食 (震脚推扇)

(30) Fierce tiger pounces on prey (thud foot push fan)

táng láng bǔ chán　(chuō jiǎo liáo shàn)
(三十一) 螳螂捕蝉 (戳脚撩扇)

(31) Praying mantis catching cicadas (heel kick flick fan inward)

lè mǎ huí tóu　(gài bù àn shàn)
(三十二) 勒马回头 (盖步按扇)

(32) Rein in horse to look back (cover stance press fan)

yào zǐ fān shēn　(tuì bù cáng shàn)
(三十三) 鹞子翻身 (退步藏扇)

(33) Harrier turns over (step back, coil and hide fan)

zuò mǎ guān huā　(mǎ bù jī shàn)
(三十四) 坐马观花 (马步击扇)

(34) Sitting on a horse looking at flowers (horse stance flash fan)

第五段 Fifth section

(三十五) 顺鸾肘 shùn luán zhǒu （马步顶肘 mǎ bù dǐng zhǒu） (35) Smooth elbow strike (horse stance elbow strike)

(三十六) 裹鞭炮 guǒ biān pào （马步砸拳 mǎ bù zá quán） (36) Wrapping firecrackers (horse stance and punch)

(三十七) 前招势 qián zhāo shì （虚步拨扇 xū bù bō shàn） (37) Forward sweep (Empty stance sweep with fan)

(三十八) 双震脚 shuāng zhèn jiǎo （震脚劈扇 zhèn jiǎo pī shàn） (38) Double foot stamp (thud feet chop fan)

(三十九) 龙虎相交 lóng hǔ xiàng jiāo （蹬脚推扇 dēng jiǎo tuī shàn） (39) Dragon and tiger cross paths (kick foot push fan)

(四十) 玉女穿梭 yù nǚ chuān suō （拧身亮扇 nǐng shēn liàng shàn） (40) Jade maiden works the shuttles (twist body flash fan)

(四十一) 天女散花 tiān nǚ sàn huā （云扇合抱 yún shàn hé bào） (41) Heavenly maiden scatters flowers (cloud fan and embrace)

(四十二) 霸王扬旗 bà wáng yáng qí （歇步亮扇 xiē bù liàng shàn） (42) Overlord raises a flag (rest stance flash fan)

(四十三) 行步过门 háng bù guò mén （托扇行步 tuō shàn háng bù） (43) Embrace fan and pass through doorway (carry fan while walking)

第六段 Sixth section

(四十四) 七星手 qī xīng shǒu （虚步掤扇 xū bù bīng shàn） (44) Seven-star hand (empty stance ward-off with fan)

(四十五) 揽扎衣 lǎn zhā yī （弓步掤扇 gōng bù bīng shàn） (45) Tuck in robes (bow stance ward-off with fan)

(四十六) 捋挤势 lǚ jǐ shì （后捋前挤 hòu lǚ qián jǐ） (46) Pull back and press (pull back, press forwards)

(四十四) 苏秦背剑 sū qín bèi jiàn （并步背扇 bìng bù bèi shàn） (47) Su Qin holds sword behind back (close stance fan behind back)

(四十八) 搂膝拗步 lǒu xī niù bù （弓步戳扇 gōng bù chuō shàn） (48) Brush knee twist stance (bow stance thrust fan)

(四十九) 单鞭下势 dān biān xià shì （仆步穿扇 pú bù chuān shàn） (49) Low single whip (crouch stance thread fan)

(五十) 挽弓射虎 wǎn gōng shè hǔ （弓步架扇 gōng bù jià shàn） (50) Drawing a bow to shoot the tiger (bow stance lift up fan)

(五十一) 白鹤亮翅 bái hè liàng chì （虚步亮扇 xū bù liàng shàn） (51) White crane flashes wings (empty stance flash fan)

(五十二) 收势 shōu shì （抱扇还原 bào shàn hái yuán） (52) Closing form (encircle with fan and return to origin)

太極功夫扇教學圖解
Step by step instructional guide to Taiji Kungfu Fan

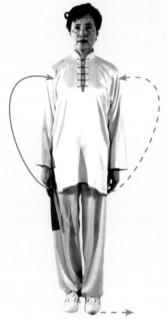

图1

yù bèi shì
預備勢　Preparatory Form

并步站立（假設面向正南），兩臂自然垂于體側。右手持握扇根，扇頂朝下。目視前方（圖1）。

要點：頭頸正直，身體自然放鬆。

Preparatory Form

Stand with feet together (nominally facing south), arms hanging naturally on each side. Hold base of fan in right hand, tip of fan pointing down. Look ahead (Figure 1).

Key points: Keep head and neck upright and body naturally relaxed.

第一段
First section

qǐ shì　　(kāi bù bào shàn)
（一）起勢（開步抱扇）
(1) Opening form (open step encircle with fan)

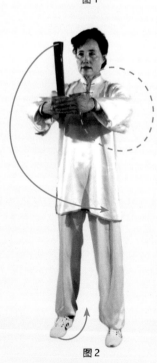

图2

左脚向左分開半步，與肩同寬。同時兩臂從身體兩側合抱于胸前，臂與肩平，兩臂撐圓。右手握扇，扇頂向上；左手在外，四指貼于右拳背。目視前方（圖2）。

要點：表演時也可先抱扇敬禮，然后左脚向左開步。

(1) Opening form (open step encircle with fan)

Step left foot half a step to the left, shoulder width apart. At the same time, raise arms from either side to front of chest, arms and shoulders level, arms rounded. Hold fan in right hand, tip of fan pointing up; left hand outermost, fingers on back of right fist. Look ahead (Figure 2).

Key points: When performing, you may also hold the fan and salute, and then move your left foot to the left.

xié fēi shì　　(cè gōng jǔ shàn)

（二）斜飛勢（側弓舉扇）

(2) Oblique flying (side bow stance raise fan)

1、收腳抱手：左手向左下、向上劃弧，屈臂抱于胸前；右手向右上、向下劃弧，屈臂抱于腹前，手心上下相對。右腳提起收于左腳內側。目視左手（圖3）。

2、開步插手：右腳向右側伸出，腳跟着地。同時兩臂交叉相抱，左臂在上。目視右扇（圖4）。

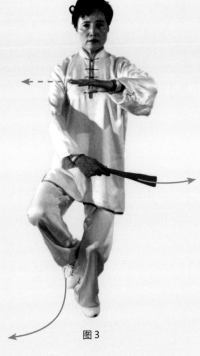

图3

图4

(2) Oblique flying (side bow stance raise fan)

1. Close feet encircle hands: draw left hand in an arc to the **lower left and then** upwards, to front of chest; draw right hand in an arc to upper right and then downwards, to front of belly, palms facing each other. Lift right foot to inside of left foot. Look at left hand (Figure 3).

2. Open step cross hands: extend right foot to the right, landing with heel. At the same time arms pass across each other, left arm uppermost. Look at the right fan (Figure 4).

3、側弓步舉扇：重心右移，成側弓步（橫襠步）。上體稍右傾，兩手分別向
右前上方和左前下方撐開。右手舉扇略高于頭，掌心斜向上；左掌與胯同高，
掌心斜向下。轉頭向左平視（圖5）。

要點：

1、開步插手時，兩臂斜上斜下交叉。

2、舉扇分靠時上體側傾，頭與軀干保持順直舒展，沉肩頂頭。本勢采自吳式
太極拳，要求上體斜中寓正，以肩向右側擠靠。

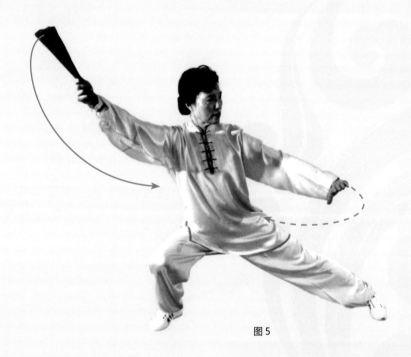

图5

3. Side bow stance lift fan: Shift weight right to form side bow stance. Lean upper body slightly to the right, spread hands to upper right and lower left. Raise fan in right hand slightly above head, palm facing up; left palm level with hip, palm facing down. Turn head to look left (Figure 5).

Key points:

1. In the 'open step cross hands' form, arms cross diagonally upwards and downwards.

2. In the 'lift fan and lean' form, lean upper body, but keep head and torso upright and relaxed, and dip shoulder and top of head. This form is taken from Wu-style Taijiquan, which requires the upper body to be inclined but upright, the shoulder pressing to the right.

bái hè liàng chì　（xū bù liàng shàn）

（三）白鶴亮翅（虛步亮扇）

(3) White crane flashes its wings (empty stance flash fan)

1、轉腰擺扇：重心左移，身體左轉。右手持扇向左擺至頭前；左掌收至右腰間，掌心向上。目視前方（圖6）。

2、轉腰分掌：重心右移，身體右轉。右手持扇向下、向右劃弧擺至右胯旁；左掌經右臂內側穿出向左劃弧至頭左側。目視右前方（圖7）。

(3) White crane flashes its wings (empty stance flash fan)

1. Turn waist swing fan: Shift weight left, turn body left. Swing fan in right hand left to front of head; draw left palm to right waist, palm facing up. Look ahead (Figure 6).

2. Turn waist part palms: shifts weight right, turn body right. Swing fan in right hand downwards to the right beside right hip; pass left palm through inside of right arm and draw in an arc leftwards to left of head. Look ahead and right (Figure 7).

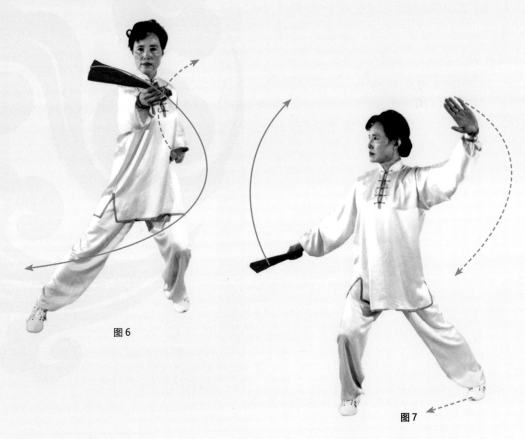

图6

图7

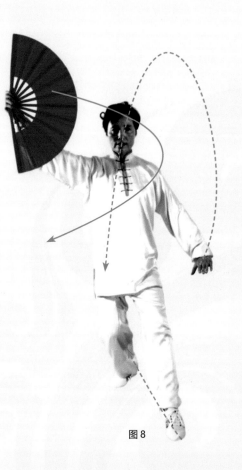

图 8

3、虚步亮扇：身體轉正，左脚向前半步
成左虚步。兩掌繼續向左下和右上劃弧，
左掌按在左胯旁；右手在頭右前上方，
抖腕側立開扇。目視正前方（圖 8）。
要點：
1、重心移動、轉腰、兩臂揮擺要協調配
合，行動一致。
2、虚步與亮扇要同時完成。扇骨上下竪
直，扇正面（光滑面）朝前，背面（小
扇骨面）朝后，扇沿向左。
3、本勢采自楊式太極拳，要求中正安舒。

3. Empty stance flash fan: Turn body right, step left foot half a step forwards and adopt empty stance. Continue to arc palms to the lower left and upper right, pressing left palm down beside left hip; right hand to the upper right front of head, flick wrist sideways to open fan. Look straight ahead (Figure 8).

Key points:
1. Shift weight, turn waist, swing arms should all be in harmony and in unison.
2. Empty stance, flash fan should be completed at the same time. The fan ribs are upright up and down, the smooth front of the fan forwards, the ribbed back of the fan backwards, the edge of the fan left.
3. This form is taken from Yang-style Taijiquan, which is centred and serene.

huáng fēng rù dòng (jìn bù cì shàn)

（四）黃蜂入洞（進步刺扇）

(4) Yellow bee enters a cave (step forward and thrust fan)

1、合扇收腳：右手抖腕先將扇合上。繼而身體先向左轉，再向右轉，左腳提起收于右小腿內側。同時右手持扇先向左擺，再翻掌向右平帶，將扇橫置于右肩前，扇頂向左；左掌上繞經面前落在右臂內側，手心向下。目視右前方（圖 9 ）。

2、轉身上步：身體左轉，左腳向前（東）上步，腳尖外撇。同時右手持扇向下卷裹收于腰側；左掌亦隨之翻轉落于腹前。目視前方（圖 10 ）。

(4) Yellow bee enters a cave (step forward and thrust fan)

1. In the 'open step cross hands' form, arms cross diagonally upwards and downwards.

2. In the 'lift fan and lean' form, lean upper body, but keep head and torso upright and relaxed, and dip shoulder and top of head. This form is taken from Wu-style Taijiquan, which requires the upper body to be inclined but upright, the shoulder pressing to the right.

1. Close fan feet together: first flick wrist to close fan in right hand. Then turn body first left, then right, lift left foot to inner right calf. At the same time, swing fan in right hand to left, then flip right palm and draw level to the left: fan is horizontal in front of right shoulder, tip of fan pointing left; drop left palm to inside of right arm in front of the centre-line, palm facing down. Look ahead and right (Figure 9).

2. Turn body step forwards: Turn body left, step left foot forwards (east), angle toes outward. At the same time, roll fan in right **hand downwards around waist; also drop** left palm to front of abdomen. Look ahead (Figure 10).

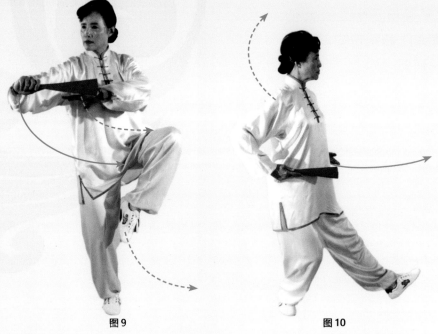

图 9　　　　　　　　　图 10

3、弓步平刺: 右腳向前上步，重心前移成右弓步。同時右手持扇向前刺出，高與胸平，手心向上；左掌向左、向上繞至頭側上方。目視前方（圖11）。

要點：

1、右手先合扇，繼而以腰帶臂，以臂帶扇，收腳、橫扇與左掌繞轉要同時完成。

2、扇卷落時，右臂外旋，手心向上，扇頂指向前方。

3、刺扇時轉腰順肩，扇與右臂成直綫。

4、本勢采自三十二式太極劍，要求上體松正安舒，步法輕起輕落。

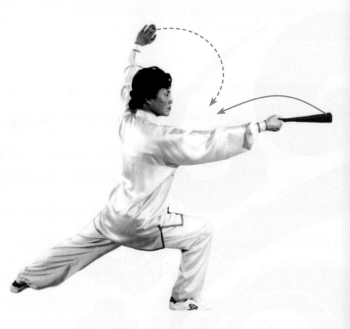

图 11

3. Bow stance level stab: Step right foot forwards, shift weight forwards and adopt right bow stance. At the same time, stab fan in right hand forwards, chest-height and level, palm facing up; spiral left palm to the left and upwards beside head. Look ahead (Figure 11).

Key points:

1. First close fan with right hand, then waist leads arm, arm leads fan. Lift foot, draw fan horizontally and rotate left palm should all happen at the same time.

2. In the 'roll fan downwards' form, rotate right arm outwards, palm facing up, tip of fan pointing forwards.

3. In the 'stab fan' form, turn waist followed by shoulders, fan in line with right arm.

4. This form is taken from 32-form Taiji sword, which requires that the upper body is relaxed and serene, and the footwork rises and falls gently.

nǎ zhà tàn hǎi　　(zhuǎn shēn xià cì)

（五）哪吒探海（轉身下刺）

(5) Deity Ne Zha probes the sea (turn body thrust downwards)

1、后坐收扇：左腿屈膝，重心后移；右腿自然伸直，脚尖上翘。右手持扇横收于胸前，手心向上；左手落于右手上方，手心向下。目视前方（图12）。

2、扣脚轉體：右脚尖内扣落地，隨之重心右移，右脚蹬地碾轉，向左后轉體；左腿提收于右小腿内側。右手握扇收至右腰側。目視左前方（圖13）。

(5) Deity Ne Zha probes the sea (turn body thrust downwards)

1. Sit back close fan: Bend left leg, shift weight backwards; straighten right leg, tip toes up. Draw fan in right hand horizontally in front of chest, palm up; drop left hand on top of right hand, palm down. Look ahead (Figure 12).

2. Twist foot turn body: twist right toes inward and drop, then shift weight right, spin on ball of right foot, turning body to the rear and left; lift left foot and draw to inner right calf. Draw fan in right hand beside right waist. Look ahead and left (Figure 13).

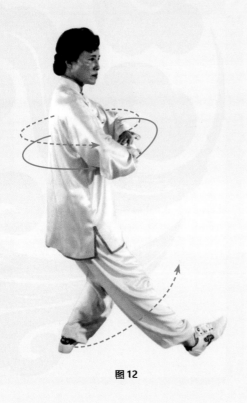

图12

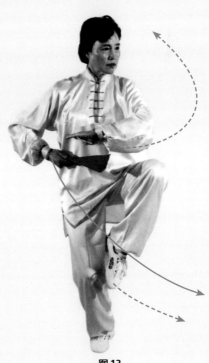

图13

3、弓步下刺：左腳向左前（東南）落地成左弓步。同時，左掌向左向上劃弧舉于頭側上方；右手握扇向前下方（東南）刺出，手心朝上。目視前下方（圖14）。

要點：

1、后坐收扇時，身體向左、向右轉動；右手持扇向左、向右劃弧收于胸前。

2、此勢采自四十二式太極劍。碾腳轉體時，立腰、豎頸、頂頭、提膝，身體保持端正平穩。弓步刺扇時上體略向前傾。

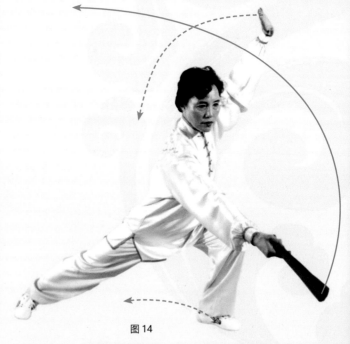

3. Bow stance stab downwards: Drop left foot forwards and left (southeast) and adopt left bow stance. At the same time, draw left palm in an arc to the left and upwards and lift above side of head; stab fan in right hand forwards and downwards (southeast), palm facing up. Look ahead and downwards (Figure 14).

Key points:

1. In the 'sit back draw fan' form, turn body left then right; draw fan in right hand left then right and bring to front of chest.

2. This form is taken from 42-form Taiji sword. In the 'spin on foot turn body' form, ensure waist, neck, tip of head, and raised knee are all upright to keep body upright and stable. Lean slightly forward in the 'bow stance stab downwards' form.

图14

jīn jī dú lì (dú lì liáo shàn)

（六）金鶏獨立（獨立撩扇）

(6) Golden rooster stands on one leg (stand on one leg raise fan)

1、收脚繞扇：身體右轉，重心后移，左脚收至右脚内側。右手持扇向上、向后劃弧繞轉，舉于頭右側上方；左掌隨之向右劃弧至右肩前。目視右扇（圖15）。

2、上步繞扇：身體左轉，左脚向前（正東）上步，脚尖外撇。右手持扇繼續向右下劃弧繞轉；左掌隨之向下劃弧至腹前。目視右扇（圖16）。

(6) Golden rooster stands on one leg (stand on one leg raise fan)

1. Feet together spiral fan: turn body right, shift weight backwards, draw left foot to inside of right foot. Draw fan in right hand in an arc upwards and backwards, to upper right side of head; then draw left palm in an arc to the right, to front of right shoulder. Look at right fan (Figure 15).

2. Step forwards spiral fan: turn body left, step left foot forwards (east), angle toes outward. Continue drawing fan in right hand to the right and downwards; then draw left palm in an arc downwards to front of abdomen. Look at right fan (Figure 16).

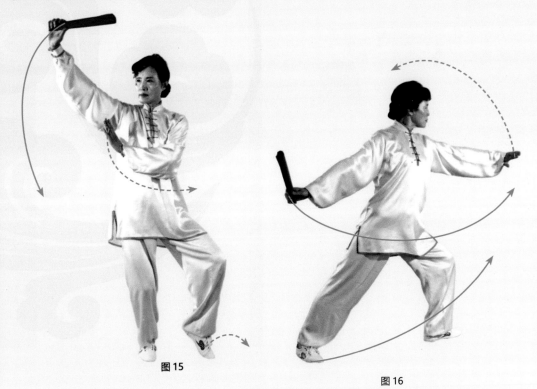

图15

图16

3、獨立撩扇：身體左轉，右腳提起成左獨立步。右手持扇向前上劃弧撩起，至肩平時抖腕平直開扇；左掌劃弧舉至頭側上方。目視前（東）方（圖 17）。

要點：

1、轉腰、收脚、上步與繞扇要協調一致。

2、提膝、開扇要同時完成。身體要保持中正穩定。

3、開扇后扇骨平直，扇沿向上，扇面與地面垂直。

3. Stand on one leg lift fan: Turn body left, lift right foot and stand on left leg. Draw fan in right hand in an arc upwards, when at shoulder level flick wrist to open fan level and straight; draw left palm in an arc to upper side of head. Look ahead (east) (Figure 17).

Key points:

1. Turn waist, close feet, step forward, spiral fan should all be in harmony.

2. Lift knee, open fan must be completed at the same time. Body must be stable and upright.

3. After opening fan, the ribs are level, edge pointing up, surface is perpendicular to the ground.

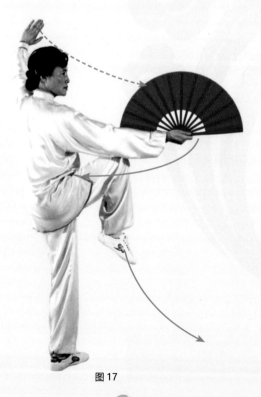

图 17

lì pī huá shān　（fān shēn pī shàn）

（七）力劈華山（翻身劈扇）

(7) Split Mountain Hua (turn over chop fan)

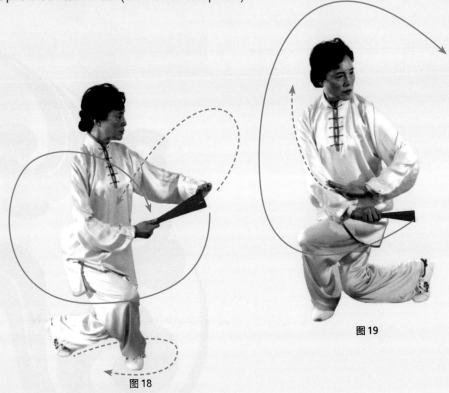

图19

图18

1、落腳合扇：上體右轉，右腳下落，腳尖外撇，左腳跟提起，兩腿略蹲。同時右手后抽；左掌下落前推，順勢合扇。目視左前（東）方（圖18）。

2、蓋步按扇：上體繼續右轉，左腳經右腳前向右蓋步，右腳跟提起。同時兩手經體側劃弧上舉，繞至頭前兩手相合按于左腹前，左掌蓋壓在右腕上。目視扇頂（圖19）。

(7) Split Mountain Hua (turn over chop fan)

1. Drop foot close fan: turn upper body right, drop right foot, angle toes outward, raise left heel, squat slightly. At the same time, drop left palm and push forwards, while drawing fan in right hand backwards through left palm, closing fan. Look ahead and left (east) (Figure 18).

2. Cover step press fan: continue turning upper body right, cross left foot in front of right foot to the right in a cover step, lift right heel. At the same time, draw both hands in an arc to either side, lift and bring together in front of head, press both hands down to front of left abdomen, left palm on right wrist. Look at tip of fan (Figure 19).

3、翻身繞扇：以兩腳掌爲軸，上體挺胸展腹向右
後翻轉。同時右手持扇隨轉體向上、向前繞擺，舉
至頭上；左掌收于胸前。目視右扇（圖20）。

4、弓步劈扇：身體繼續右轉，右腳向前（東）上步，
成右弓步。右手持扇下劈倒立開扇；左掌向下、向
左劃弧，舉于頭側上方。目視前方（圖21）。

要點：

1、蓋步按扇要以腰爲軸，帶動四肢。轉腰合胯，
提腿蓋步，繞臂按扇要協調一致。

2、翻身繞扇時，扇要貼身走立圓。

3、弓步劈扇方向爲正東，右臂與肩同高。下劈開
扇后扇骨水平，扇面側立，扇沿向下。

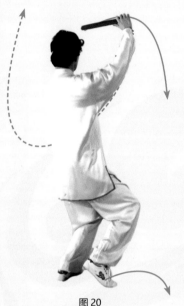

图20

3. Turn over spiral fan: Turn body to the left and rear on balls of feet, chest straight and abdomen taught. At the same time, swing fan in right hand upwards and forwards as the body turns, lift above head; draw left palm to front of chest. Look at right fan (Figure 20).

4. Bow stance chop fan: Continue turning right, step right foot forwards (east), adopt right bow stance. Chop fan in right hand downwards, opening fan; draw left palm in an arc downwards to the left, and lift above side of head. Look ahead (Figure 21).

Key points:

1. In the 'cover step press fan' form, use waist as axis to drive the limbs. Turn waist, close hips; raise leg, cross step; spiral arms, press fan; should all be in harmony.

2. In the 'turn over spiral fan' form, the fan should pass close around the body.

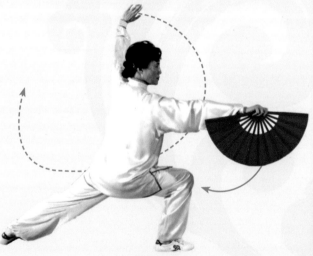

图21

3. The 'bow stance chop fan' form is due east, right arm at shoulder height. After chopping fan downwards, the ribs are level, surface to the side, edge pointing down.

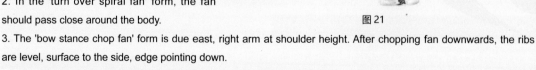

（八）靈猫捕蝶（翻身掄壓）

(8) Nimble cat catches butterfly (turn over, swing and press)

1、轉體擺掌：身體左轉，重心左移，右弓步變左弓步。同時左掌向右、向下、向左劃弧擺至體前（正西）；右手持扇翻轉下沉，背于身後。頭隨身轉，目視正西（圖22）。

2、上步掄扇：右脚上步，脚尖内扣，挺胸展腹，翻身左后轉。右手持扇向前、向上掄擺劃弧；左掌向上、向后掄擺劃弧，兩臂伸展。頭隨體轉（圖23）。

(8) Nimble cat catches butterfly (turn over, swing and press)
1. Turn body swing palm: Turn body left, shift weight left, right bow stance becomes left bow stance. At the same time, swing left palm in an arc to the right, down, and left in front of body (west); flip fan in right hand and lower behind back. Turn head with body to look west (Figure 22).
2. Step forwards swing fan: step right foot forwards, turn toes inward, chest upright and abdomen taught, turn body over to the left and rear. Swing fan in right hand in an arc forwards and downwards; swing left palm in an arc upwards and backwards, both arms extended. Turn head with body (Figure 23).

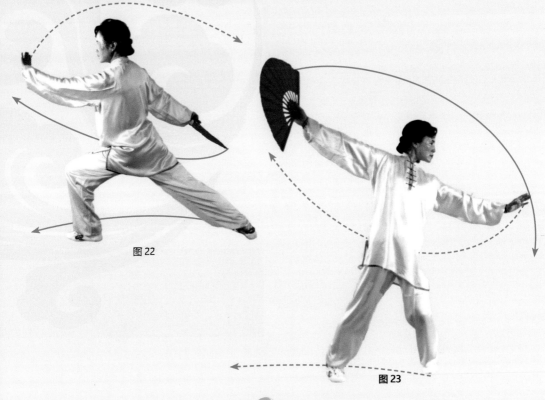

图22

图23

3、弓步壓扇：身體繼續左轉，左脚向后撤步，成右弓步。右手持扇掄擺劃弧向前下方壓扇，繼而翻轉手心向上持扇反壓；左掌掄擺劃弧舉至后上方，手臂內旋，手心向后。目視前下方（圖24）。

要點：

1、上步翻身掄扇要以腰帶臂，兩臂掄擺成立圓。掄扇時扇面與掄擺弧綫保持垂直。

2、正反壓扇時，扇面接近水平，略低于膝。兩臂向前下方和后上方伸直；s。弓步方正東。

3. Bow stance press fan: Continue turning left, step left foot backwards and adopt right bow stance. Swing fan in right hand in an arc and press forwards and downwards, then flip fan in right hand and lift and press with back of hand; swing left palm in an arc to the upper rear, rotate arm inwards, palm facing to the rear. Look ahead and downwards (Figure 24).

Key points:

1. in the step forward, turn body, swing fan sequence, waist leads arms as arms swing in a circle. In the 'swing fan' form, the fan surface is perpendicular to the arc of the fan.

2. In the 'press and lift fan' form, the surface is close to level, slightly lower than the knee. Both arms are straight, forwards and downwards and backwards and upwards; upper body leaning forwards. Bow stance is due west.

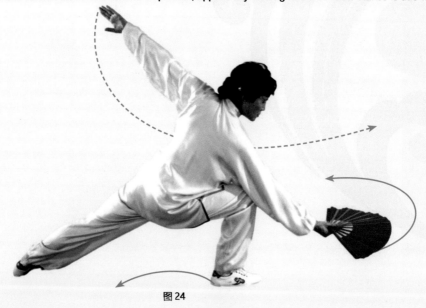

图24

zuò mǎ guān huā（mǎ bù jī shàn）

（九）坐馬觀花（馬步擊扇）

(9) Sitting on a horse gazing at flowers
　　(horse stance flash fan)

1、虛步合扇：重心后移，右腳回收半步，腳前掌
點地，成右虛步。左掌屈收，經胸前向前推出；
右手持扇回收至腰間，兩手交錯時順勢合扇。目
視前方（圖25）。

2、退步穿扇：右腳后退一步，同時右手持扇向后、
向上掄擺至頭頂，扇頂斜向下；左手經左肋向身
后反手穿伸（圖26）。

上體右后轉，重心右移。同時右手持扇沿體側向
右后方穿伸；左手也隨之向左后伸直。頭隨體轉，
目視正西右扇（圖27）。

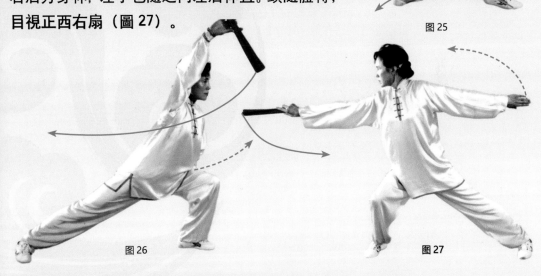

图 25

图 26

图 27

(9) Sitting on a horse gazing at flowers (horse stance flash fan)

1. Empty stance close fan: shift weight backwards, draw right foot back half a step, rest on forefoot and adopt right empty stance. Bend left arm and push palm out to front of chest; draw fan in right hand to waist, closing fan as the hands cross. Look ahead (Figure 25).

2. Step back pierce fan: step right foot backwards, at the same time swing fan in right hand backwards and upwards to tip of head, tip of fan obliquely downwards; pierce left hand across left ribs and extend behind body (Figure 26). Turn upper body to right and rear, shift weight right. At the same time, pierce fan in right hand along side of body and stretch to the right; extend left hand to the left. Turn head with body, look at right fan (due west) (Figure 27).

3、馬步擊扇：身體左轉，重心左移，成馬步。同時右手翻轉向左抖腕橫擊開扇，手心向內，與腰同高，停于右膝上方；左掌向上劃弧，舉于頭側上方，手心向上。目視扇沿（圖28）。

要點：

1、虛步合扇采自高探馬動作，要求轉腰順肩，立身中正。

2、退步穿扇時，應扇頂在前，扇骨沿體側向身后穿出。與轉身弓步同時完成。

3、馬步擊扇時，兩腳平行；扇面朝向西南。

3. Horse stance strike fan: Turn body left, shift weight left, adopt horse stance. At the same time, flip right hand and flick wrist in a horizontal strike to open fan, palm facing inwards, at waist height, stopping above right knee; draw left palm in an arc upwards, lift above side of head, palm facing up. Look at fan edge (Figure 28).

Key points:

1. 'Empty stance close fan' is taken from the 'high search on horse' form, which requires turning waist and shoulders smoothly, body upright.

2. In the 'step back pierce fan' form, leading with tip of fan, the fan ribs pierce out along the side and behind the body.

3. In the 'horse stance strike fan' form, the feet are parallel, the fan faces southwest.

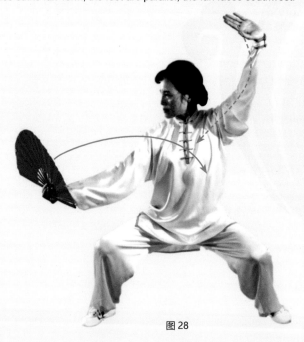

图28

第二段
Second section

yě mǎ fèn zōng (gōng bù xuē shàn)
（十）野馬分鬃（弓步削扇）
(10) Part the wild horse's mane (bow stance slice fan)

1、轉腰合臂：上體左轉，右手合扇，兩臂交叉合抱于左胸前。目視左下方（圖29）。

2、弓步削扇：身體右轉，右腳尖外撇，左腿蹬直，成右弓步。兩臂向右上方和左下方分開，成一直綫。右手高與頭平，手心斜向上﹔左手高與胯平，手心斜向下。目視右扇（圖30）。

要點：

1、合臂、削扇都要以腰帶臂，腰肢協調一致。

2、此勢采自查拳動作，要求舒展挺拔，放長擊遠。弓步方向正西。

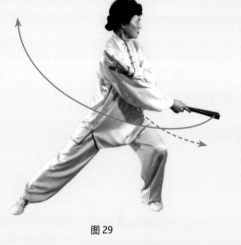

图29

(10) Part the wild horse's mane (bow stance slice fan)

1. Turn waist close arms: turn upper body left, close fan with right hand, bring arms together and cross in front of left chest. Look left and downwards (Figure 29).
2. Blow stance slice fan: Turn body right, angle right toes outward, thrust with left leg, adopt right bow stance. Separate arms to upper right and lower left to form a straight line. Right hand level at head height, palm facing up; left hand level at waist height, palm facing down. Look at fan (Figure 30).

Key points:

1. In the close arms, slice fan sequence, waist leads arms, the movements in harmony with the waist.
2. This form is taken from a Chaquan movement, which requires stretching tall and straight, and lengthening to strike farther. Bow stance is due west.

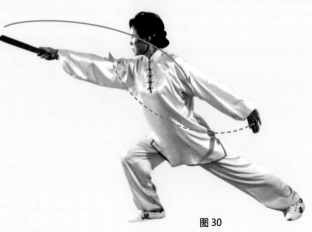

图30

chú yàn líng kōng (bìng bù liàng shàn)

（十一）雛燕凌空（并步亮扇）

(11) Young swallows soar in the sky (closed stance flash fan)

1、轉腰穿掌：重心不動，右腳尖內扣，身體左轉。右手握扇向左、向下劃弧至左肩前；左掌向右、向上經右臂內側穿出，兩臂在胸前交叉，掌心均向內；目視右手扇（圖31）。

(11) Young swallows soar in the sky (closed stance flash fan)

1. Turn waist cross palms: Keep weight centred, twist right toes inward, turn body left. Draw fan in right hand in an arc to the left and downwards past front of left shoulder; pass left palm to the right and upwards to inside of right arm, crossing arms in front of chest, palms facing inwards. Look at right fan (Figure 31).

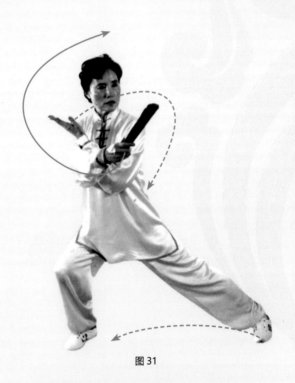

图 31

2、并步亮扇：身體先右轉再左轉，左脚收至右脚旁，兩腿直立，成并步。右手握扇向下、向右、向上劃弧，至頭右上方時抖腕側立開扇；左掌向上、向左、向下劃弧，抱拳收于左腰間。向左甩頭，目視左（東）側（圖32）。

要點：

1、此勢爲長拳動作，要求頂頭、挺胸、收腹，身體挺拔直立。

2、并步、抱拳、開扇、轉腰、甩頭，要協調一致，干脆有力。

3、亮扇方法同（三）白鶴亮翅，唯右手直臂上舉。

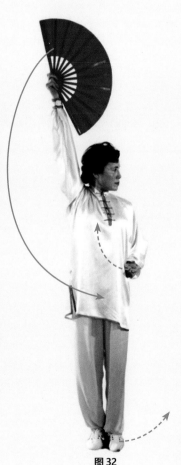

2. Parallel stance flash fan: turn body first right then left, draw left foot beside right foot, stand upright on both feet, adopt parallel stance. Draw fan in right hand in an arc downwards, right, and upwards. At upper right of head, flick wrist to open fan; draw left palm in an arc upwards, left, and downwards, form a fist and draw beside left waist. Flick head left, look left (east) (Figure 32).

Key points:

1. This form is a Changquan (Long Fist) movement, which requires head up, chest upright, abdomen taught, body straight and upright.

2. Parallel stance, form fist, open fan, turn waist, flick head must all be in harmony with clear expression of force.

3. The 'flash fan' technique is the same as (3) White crane flashes its wings, except the right hand is raised straight up.

图32

huáng fēng rù dòng (jìn bù cì shàn)

（十二）黃蜂入洞（進步刺扇）

(12) Yellow bee enters a cave (step forward and thrust fan)

1、擺掌上步：身體先右轉再左轉，左腳向左（正東）上步。右手翻掌合扇，向右、向下卷收到右腰間；左拳變掌，向左、向上、向右劃弧至右胸前，掌心向右。目視左（東）前方（圖33）。

(12) Yellow bee enters a cave (step forward and thrust fan)
1. Swing palm step forwards: Turn body first right then left, step left foot to the left (east). Flick right palm to close fan, roll to the right and down beside right waist; left fist becomes palm, draw in an arc to left, upwards, right, to front of right chest, palm facing right. Look ahead and left (east) (Figure 33).

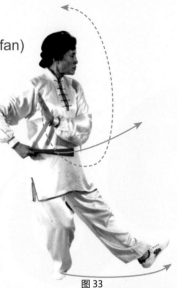

图 33

2、弓步直刺：上體左轉，右腳向前上步，左腳蹬直，成右弓步。右手握扇前刺，手心向上，與肩同高；左掌向左、向上劃弧繞至頭左上方，掌心向上。目視右扇（圖34）。

要點：

1、刺扇與弓步要協調一致。

2、動作要干脆利落，舒展有力。

2. Bow stance level stab: Turn upper body left, step right foot forwards, thrust left foot, adopt right bow stance. Stab fan in right hand forwards, palm facing up, shoulder height; draw left palm in an arc left and upwards to upper left of head, palm facing up. Look at fan (Figure 34).

Key points:
1. Stab fan and bow stance should be in harmony.
2. Movements should be crisp and neat, the stretch forceful.

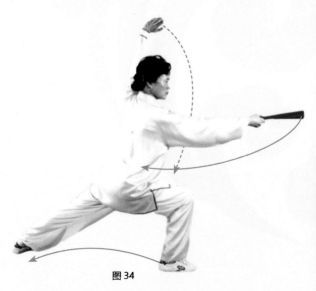

图 34

měng hǔ pū shí (zhèn jiǎo tuī shàn)

（十三）猛虎撲食（震脚推扇）

(13) Fierce tiger pounces on prey (thud foot push fan)

1、震脚收扇：重心后移，右脚收至左脚內側踏震落地；左脚迅速提起，靠近右踝內側。同時右手握扇收至右腰間，手心向左；左掌向下收于左腰間，手心向右；兩手貼緊身體，虎口斜向上。目視前方（圖 35）。

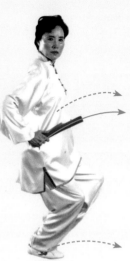

(13) Fierce tiger pounces on prey (thud foot push fan)

1. Thud foot draw fan: shift weight backwards, draw right foot to inside of left foot and drop with a thud; lift left foot quickly and bring to inside of right ankle. At the same time, draw fan in right hand beside right waist, palm facing left; draw left palm down beside left waist, palm facing right; keep hands close to body, thumb and forefinger inclined upwards. Look ahead (Figure 35).

图 35

2、弓步推扇：左脚向前上步，右腿蹬直，成左弓步。同時兩手向體前推出，左掌沿與右拳面朝前，手心相對，腕與肩同高；扇身竪直，目視前方（圖 36）。

要點：

1、此勢爲長拳動作，要求快速有力，干脆利落。

2、震脚時，提脚高不過踝，踏落全脚着地，快速有力。兩脚換接緊密，不可跳躍。

2. Bow stance push fan: Step left foot forwards, thrust right leg, adopt left bow stance. At the same time, push both hands forwards, left palm-edge and right fist-face forwards, palms facing each other, wrists at shoulder height; fan standing upright. Look ahead (Figure 36).

Key points:

1. This form is a Changquan (Long Fist) movement, which requires fast, crisp and neat expression of force.

2. In the 'thud foot' form, lift the foot higher than the ankle, drop the foot flat on the ground, fast and powerful. The two feet are equally balanced – do not jump.

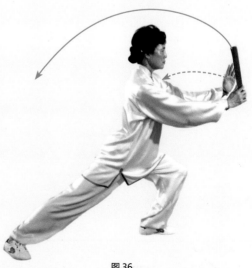

图 36

35

táng láng bǔ chán (chuō jiǎo liáo shàn)

（十四）螳螂捕蟬（戳脚撩扇）

(14) Praying mantis catching cicadas (heel kick flick fan inward)

1、轉腰繞扇：身體右轉，重心后移。右手內旋向上、向后劃弧繞扇；左掌附于右腕隨之劃弧。目視右手（圖37）。

2、分手繞扇：身體左轉，重心前移，左脚尖外撇。右手握扇繼續向下繞弧；左掌向下、向左劃弧擺至肩高。目視左手（圖38）。

(14) Praying mantis catching cicadas (heel kick flick fan inward)

1. Turn waist spiral fan: turn body right, shift weight backwards. Rotate right hand inwards and draw in an arc spiraling upwards and backwards; place left palm on right wrist and then draw in an arc. Look at right hand (Figure 37).

2. Part hands spiral fan: turn body left, shift weight forwards, angle left toes outward. Continue circling fan in right hand downwards; swing left palm downwards and to the left then upwards to shoulder height. Look at left hand (Figure 38).

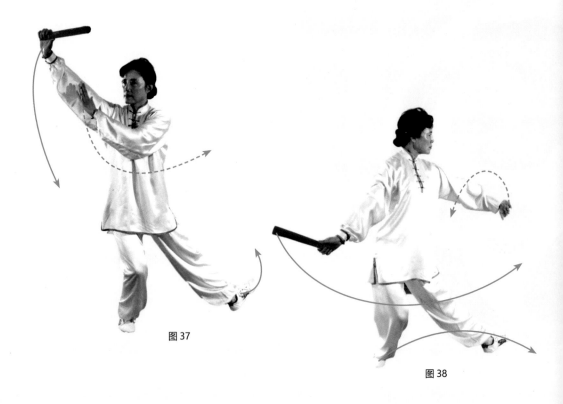

图37

图38

3、戳脚撩扇：上體左轉，右腳向前方戳踢，腳尖上翹，腳跟着地成右虛步。右手持扇向前下方撩起斜立開扇，手心斜向上；左掌收至右臂內側，掌心向右。目視扇沿（圖 39）。

要點：

1、戳脚要求腳跟擦地，腳尖上翹，小腿向前擺踢。

2、開扇方向爲正東，扇骨與右臂平行斜向前下方，右手高與腹平；扇面斜立在右腿前上方。

3. Poke foot lift fan: Turn upper body left, poke and kick right foot forwards, toes tilted up, heel touches the ground in a right empty stance. Lift fan in right hand obliquely forwards and downwards to open fan, palm facing up; left palm drawn to inside of right arm, palm facing right. Look at fan edge (Figure 39).

Key points:
1. Poke foot requires heel to brush ground, toes up, kicking lower leg forwards.
2. The open fan points east, fan ribs parallel to right arm and obliquely forwards and downwards above right leg, right hand at level of abdomen.

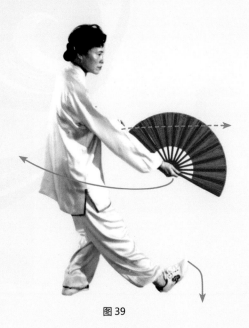

图 39

lè mǎ huí tóu　　(gài bù àn shàn)

（十五）勒馬回頭（蓋步按扇）

(15) Rein in horse to look back (crossover stance press fan)

1、合扇轉身：身體右轉，重心前移，右腳落實，腳尖外撇，左腳跟提起。同時右手持扇后抽；左掌前推合扇，兩臂向左右分開。目視右扇（圖 40）。

2、蓋步按扇：上體右后轉，左腳經右腳前向右蓋步，右腳跟提起。同時兩手向上、向內劃弧于頭前相合，再按至左腹前，左掌壓在右腕上。目視扇頂（圖 41）。

要點：

轉體蓋步要以腰爲軸 轉腰揮臂，提腿合胯，蓋步按扇，動作連貫銜接，協調配合。

(15) Rein in horse to look back (crossover stance press fan)

1. Close fan turn body: turn body right, shift weight forwards, drop right forefoot, angle toes outward, lift left heel. At the same time, push left palm forwards and draw fan in right hand backwards through left palm closing fan, separate arms to left and right. Look at right fan (Figure 40).

2. Cover step press fan: turn upper body to the right and rear, cross left foot in front of right foot to the right in a cover step, lift right heel. At the same time, draw both hands in an arc upwards and inwards to meet in front of head, then press down to front of left abdomen, left palm on right wrist. Look at tip of fan (Figure 41).

Key points:

The 'turn body cover stance' form uses the waist as axis; turn waist, close hips; raise leg, cross step; spiral arms, press fan; should all be in harmony.

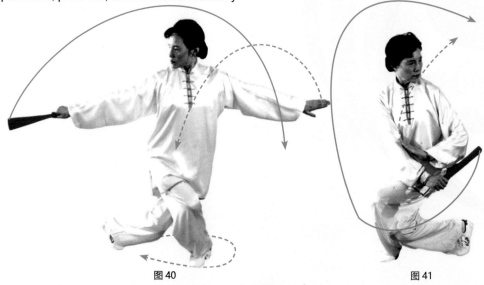

图 40　　　　　　　　　　图 41

yào zǐ fān shēn (tuì bù cáng shàn)

(十六) 鷂子翻身 (退步藏扇)

(16) Harrier turns over (step back, coil and hide fan)

1、翻身繞扇：以兩前腳掌碾地，上體挺胸展腹向右后翻轉。同時右手持扇隨轉體向上、向前繞擺至頭前上方，再以腕關節爲軸持扇挽一個腕花，使扇在右腕外側繞轉一周。左掌指仍扶于右腕部。目視右扇 (圖42)。

2、退步藏扇：右脚后退一步，左腿屈弓成左弓步；同時右手持扇向下、向后擺至身后；左手落經胸前，向前側立掌推出。目視左手 (圖43)。

要點：

1、翻身時，挺胸、仰頭、翻腰，以腰帶臂。

2、弓步推掌方向正東。

图42

(16) Harrier turns over (step back, coil and hide fan)

1. Turn over spiral fan: Turn body to the right and rear on the balls of the feet, chest upright and abdomen taught. At the same time, swing fan in right hand upwards and forwards as the body turns, then with wrist as axis revolve fan in right hand around outside of right wrist. Keep left palm on right wrist. Look at fan (Figure 42).

2. Step back hide fan: step right foot backwards, bend left leg and adopt left bow stance; at the same time, swing fan in right hand downwards and backwards behind back of body; drop left palm in front of chest and push out forwards with palm upright. Look at left hand (Figure 43).

Key points:

1. In the 'turn over' form, keep chest upright, raise head, turn waist, waist leads arms.

2. Bow stance push palm is due east.

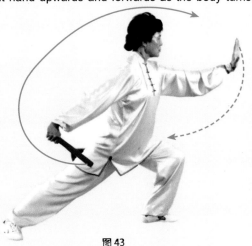

图43

zuò mǎ guān huā (mǎ bù jī shàn)

（十七）坐馬觀花（馬步擊扇）

(17) Sitting on a horse looking at flowers (horse stance flash fan)

1、返身穿扇：身體微左轉，右手持扇向上、向前掄至頭頂；左掌經肋間向后反手穿伸（圖44）。

身體迅速右后轉，重心右移成右弓步。右手持扇沿體側向身后（西）反穿伸出；左手也隨之向左后（東）伸直。頭隨體轉，目視右扇（圖45）。

(17) Sitting on a horse looking at flowers (horse stance flash fan)

1. Turn body pierce fan: turn body slightly left, swing fan in right hand upwards and forwards to tip of head; pierce left hand across left ribs and extend behind body (Figure 44).

Quickly turn upper body to right and rear, shift weight right into a partial right bow stance. Pierce fan in right hand along side of body and stretch out to the right (west); extend left hand to the left (east). Turn head with body, look at right fan (Figure 45).

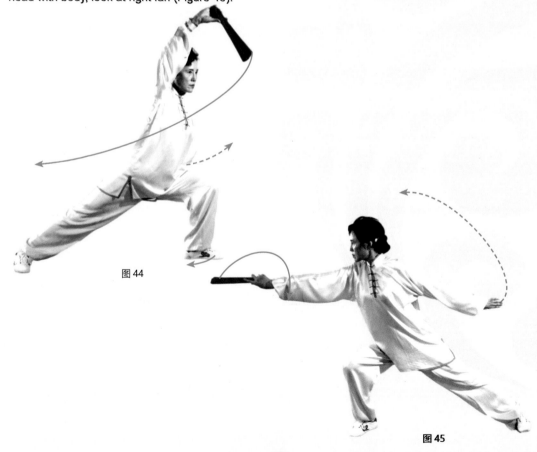

图44

图45

2、馬步擊扇：身體左轉，重心左移，成馬步。右手持扇翻轉，向左抖腕橫擊開扇，手心向內，與腰同高，停于右膝上方；左掌向上劃弧，舉于頭側上方，手心向上。目視扇沿（圖46）。

要點：

1、穿扇時扇頂領先，扇骨貼身，反手穿伸。

2、馬步擊扇時，兩腳平行；扇面朝向西南。

2. Horse stance strike fan: Turn body left, shift weight left, adopt horse stance. At the same time, flip right hand and flick wrist in a horizontal strike to open fan, palm facing inwards, at waist height, stopping above right knee; draw left palm in an arc upwards, lift above side of head, palm facing up. Look at fan edge (Figure 46).

Key points:

1. In the 'step back pierce fan' form, leading with tip of fan, the fan ribs pierce out along the side and behind the body.

2. In the 'horse stance strike fan' form, the feet are parallel, the fan faces southwest.

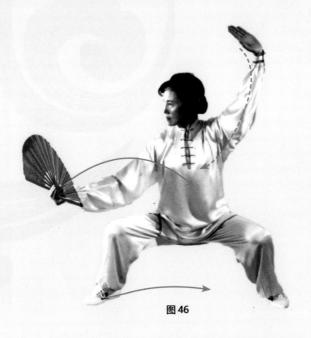

图46

第三段
Third section

jǔ dǐng tuī shān (mǎ bù tuī shàn)

（十八）舉鼎推山（馬步推扇）
(18) Lift cauldron push mountain (horse stance push fan)

1、轉體收扇：重心左移，身體右轉，右脚稍回收，脚尖點地。右手持扇收至右腰間，扇頂朝上；左掌下落與右手相合，同時順勢合扇。目視右側（圖 47）。

(18) Lift cauldron push mountain (horse stance push fan)

1. Turn body draw fan: shift weight left, turn body right, draw right foot back slightly, rest on toes. Draw fan in right hand to right waist, tip of fan pointing up; bring left palm meet right hand, at the same time closing fan. Look to the right (Figure 47).

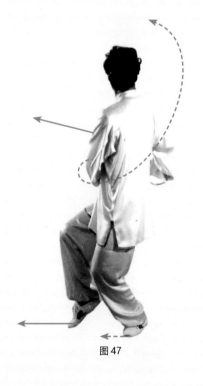

图 47

图 47（附图）

2、馬步推扇：身體向左轉，右脚向右橫跨一大步，左脚隨之滑動，成馬步，胸向正南。同時右手握扇前推，腕同肩高，扇頂竪立向上；左掌翻轉撑架在頭側上方。目視右扇（圖48）。

要點：

1、此動作采自于陳式太極劍，推扇應快速松活發力，與轉腰跨步密切配合。

2、左脚滑步應根據右脚跨步大小靈活掌握。

2. Horse stance push fan: Turn body left, take a big step to the right, slide left foot with it, adopt horse stance, chest facing south. At the same time, push fan in right hand forward, wrist at shoulder height, fan upright; flip left palm to support over side of head. Look at right fan (Figure 48).

Key points:

1. This movement is taken from Chen-style Taiji sword, 'push fan' should be a rapid release of force, closely coordinated with 'turn waist, step forwards'.

2. The left foot slide should match the size of the bid step to the right.

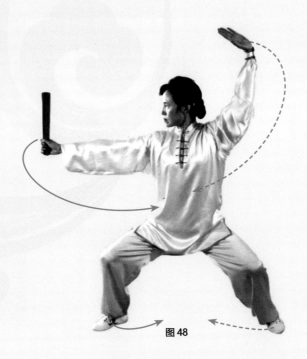

图 48

shén lóng huí shǒu (zhuǎn shēn cì shàn)

（十九）神龍回首（轉身刺扇）

(19) Spirit dragon turns its head (Turn body thrust fan)

1、轉體收扇：身體左轉，重心右移，左腳收至右腳內側，腳尖點地。兩手同時收至腰間，虎口朝前。目視前（東）方（圖 49）。

2、弓步平刺：左腳向前方邁出，屈膝前弓成左弓步。右手握扇向前刺出，腕與胸同高；左掌抱于右拳下面。目視前（東）方（圖 50）。

要點：

1、轉腰收腳與收扇收掌要協調一致。

2、弓步平刺的方向爲正東。

(19) Spirit dragon turns its head (Turn body thrust fan)

1. Turn body draw fan: turn body left, shift weight right, draw left foot to inside of right foot, rest on toes. Draw both hands beside waist at the same time, with thumb and forefinger facing forwards. Look ahead (east) (Figure 49).

2. Bow stance level stab: Step left foot forwards, bend knee and adopt left bow stance. Stab fan in right hand forwards, wrist at chest height; cup right hand in left palm. Look ahead (east) (Figure 50).

Key points:

1. Turn waist, draw foot and draw fan, draw palm should be in harmony.

2. 'Bow stance level stab' is due east.

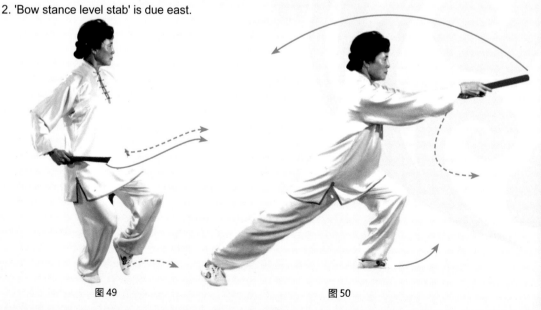

图 49　　　　　　　　　　　　图 50

huī biān cè mǎ　(chā bù fǎn liáo)

（二十）揮鞭策馬（叉步反撩）

(20) Brandish whip to urge on horse (cross step reverse flick)

1、撇腳繞扇：重心后移，左腳尖外撇，身體右轉。右手向上、向右劃弧繞至身后；左手向下、向左繞至身前。目視右扇（圖 51）。

2、上步繞扇：身體左轉，右腳向前上步，腳尖內扣。右手握扇向下、向前劃弧繞至頭側前上方；左掌翻轉收至左腰間。目視右扇（圖 52）。

(20) Brandish whip to urge on horse (cross step reverse flick)

1. Angle foot spiral fan: shift weight backwards, angle left toes outward, turn body right. Draw right hand in an arc upwards and to the right spiraling behind; draw left hand in an arc downwards and to the left spiraling in front. Look at fan (Figure 51).

2. Step forwards spiral fan: Turn body left, step right foot forwards, twist toes inward. Draw fan in right hand in an arc downwards and forwards spiraling above front of head; flip left palm and draw to left waist. Look at right fan (Figure 52).

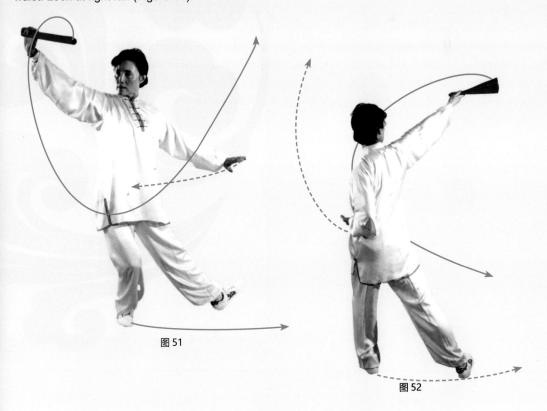

图 51

图 52

45

3、叉步反撩：身體擰腰右轉，左腳經右腳后方向右（東）插出，成右叉步。同時右手握扇向左、向下、向右反手開扇撩出；左掌向左、向上舉至頭側上方，掌心向上。目視右扇（圖 53、附圖 53）。

要點：

1、動作要連貫，叉步與開扇亮掌要整齊。

2、撩扇方向正東，右臂斜向下，右手內旋，手心向后。扇骨與右臂平行，扇沿斜向上。

3、叉步時，右腳尖外撇，右腿屈膝，左腳跟提起，左腿蹬直；塌腰挺胸，上體右轉。

3. Cross step reverse flick: bend waist and turn right, pass left foot to the right (east) behind right foot and adopt right cross step. At the same time, tease fan in right hand to the left, down, and right, back of hand facing outwards, and flick to open fan; lift left palm to the left and up above head, palm facing up. Look at fan (Figure 53).

Key points:

1. The movement should be coherent, and the cross step and the open fan flash palm should be neat.

2. 'Tease fan' is due east, right arm obliquely downwards, right hand rotated inwards, and palm facing to the rear. The fan ribs are parallel to the right arm, the fan edge obliquely upwards.

3. In the 'cross step' form, angle right toes outward, bend right knee, lift left heel, straighten left leg; bend at waist but keep chest straight, turn upper body to the right.

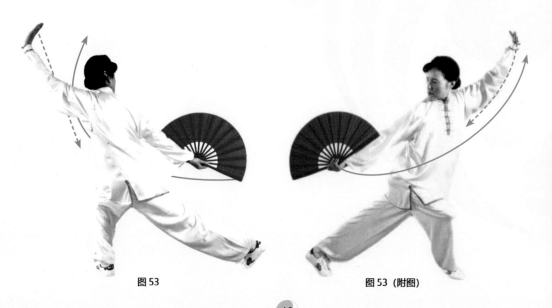

图 53　　　　　　　　　　图 53（附图）

lì mǎ yáng biān (diǎn bù tiāo shàn)

（二十一）立馬揚鞭（點步挑扇）

(21) Rearing horse raise whip (point step pluck fan)

1、轉身挑扇：身體左轉。右手持扇向前、向上挑舉至頭側上方，右臂伸直；左掌收至胸前。目視前（西）方（圖54）。

2、點步推掌：左脚上步，脚前掌輕點地面，右腿伸直，成點立步（高虛步）。同時左掌向前側立掌推出，掌心向右。目視前方（圖55）。

要點：

1、挑扇時右臂伸直擺動上舉。

2、點立步時重心在后腿，前脚掌虛點地面，兩腿皆挺膝伸直，上體向上伸拔。

3、推掌高與肩平，方向爲正西。

(21) Rearing horse raise whip (point step pluck fan)

1. Turn body pluck fan: Turn body left. Pluck fan in right hand forwards and upwards and lift above head, arm straight; draw left palm to front of chest. Look ahead (west) (Figure 54).

2. Point step push palm: Step left foot forwards, tap forefoot lightly on the ground, straighten right leg, adopt point stance (high empty stance). At the same time, push left palm out to the front, palm upright facing right. Look ahead (Figure 55).

Key points:

1. In the 'pluck fan' form, straighten right arm and swing upwards.

2. In the 'point step' form, weight is on rear leg, front forefoot is on the ground, both legs are straight, upper body is stretched upwards.

3. In the 'push palm' form, palm is at shoulder height, due west.

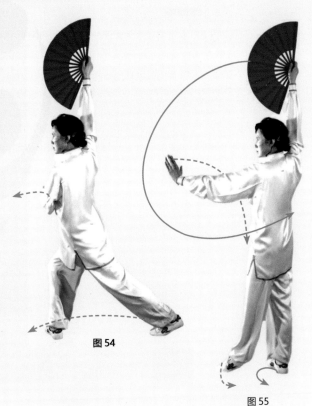

图 54

图 55

huái zhōng bào yuè (xiē bù bào shàn)
（二十二）懷中抱月（歇步抱扇）

(22) Embrace the moon (rest stance embrace fan)

歇步抱扇：左脚稍向前移動，脚尖外撇，身體左轉，兩腿交叠屈蹲成歇步。右手持扇翻轉抱于胸前，手心向内；左掌收至扇根内側，掌心斜向下。目視前（南）方（圖56）。

要點：

1、兩臂合抱貼近胸前，右手持扇在外，扇與身體平行，方向爲正南。

2、歇步時，兩腿前后交叠屈蹲，后腿膝關節貼在前腿膝窩外側。前脚尖外撇，后脚跟提起，臀部接近后脚跟。

(22) Embrace the moon (rest stance embrace fan)

Rest stance embrace fan: Turn left foot slightly forwards, angle toes outward, turn body left, squat with legs crossed and adopt rest stance. Flip fan in right hand and bring over chest, palm facing inwards; draw left palm to inside of fan base, palm facing down. Look ahead (south) (Figure 56).

Key points:

1. Bring arms together in an embrace close to chest, fan in right hand outermost, fan parallel to body, facing due south.

2. In the 'rest stance' form, squat with legs crossed one in front of the other, kneecap of rear leg to the outside of knee pit of front leg. Turn toes of front leg outward, lift rear heel, buttocks close to rear heel.

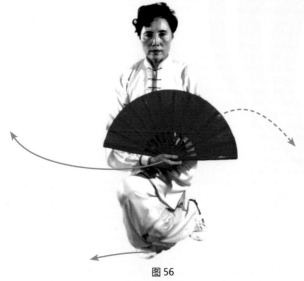

图 56

yíng fēng liáo yī (bìng bù guàn shàn)
（二十三）迎風撩衣（并步貫扇）
(23) Facing wind lifts robes (close stance round strike fan)

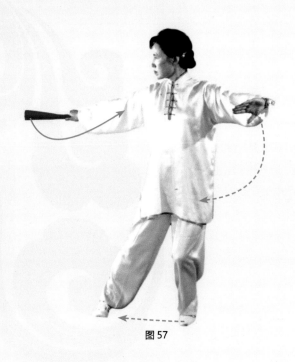

图 57

1、上步合扇：兩腿直立，身體微向右轉，右脚向右上步，脚尖内扣。同時左掌向左前方，右手向右后方分擺，順勢將扇合上。目視右側（圖57）。

(23) Facing wind lifts robes (close stance round strike fan)

1. Step forwards close fan: Stand upright on both feet, turn body slightly right, take a step to the right, turn toes inward. At the same time, part the hands, left palm to the left and forwards, right hand to the right and backwards, closing fan. Look to the right (Figure 57).

2、并步貫打：左脚向右脚并步直立，身體左轉。同時左掌變拳收至左腰間，拳心向上；右手握扇向前、向左貫打，停于右肩前，拳心向下，虎口向左。向左甩頭，目視左（東）側（圖58）。

要點：

1、此動作采自長拳動作，要求頂頭、挺胸、收腹、挺膝。貫扇與并步、轉腰、甩頭協調一致。

2、并步方向正南；甩頭方向正東。

2. Parallel stance thread fan: Bring left foot alongside right foot and stand upright, turn body left. At the same time, left palm becomes fist, draw to left waist, fist-heart (fingers) facing up; punch fan in right hand forwards and to the left, stopping in front of right shoulder, fist-heart facing down, thumb and forefinger to the left. Flick head left and look left (east) (Figure 58).

Key points:

1. This form is a Changquan (Long Fist) movement, which requires head up, chest upright, abdomen taught, knees straight. Thread fan and parallel stance, turn waist, flick head should be in harmony.

2. 'Parallel stance' is due south; 'flick head' is due east.

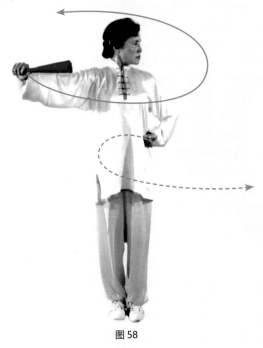

图 58

fān huā wǔ xiù　　(yún shǒu pī shàn)

（二十四）翻花舞袖（雲手劈扇）

(24) Turn over flowers to brandish sleeves (cloud hands chop fan)

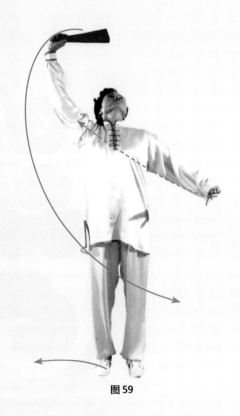

图 59

1、雲手擺扇：身體左轉，右手握扇向左平擺；左拳變掌從右腋下向右穿伸。隨之仰頭挺胸，上體右轉，右手在頭上向后、向右雲擺至右上方；左掌內旋向前、向左雲擺至身體左側。挺胸仰頭，目隨視右扇（圖 59）。

(24) Turn over flowers to brandish sleeves (cloud hands chop fan)

1. Cloud hands swing fan: Turn body left, swing fan in right hand to the left; as left fist becomes palm, stretch out from right armpit down and to the right. Then raise head and chest, turn upper body right, 'cloud' swing right hand behind head, finishing on the upper right; rotate left palm inwards and 'cloud' swing in front of body, finishing on the left. Keep head and chest up, look at right fan (Figure 59).

2、弓步劈扇：身體左轉，右腿向右側開步，左腿屈弓成側弓步。右手持扇向左前下方斜劈；左掌收至右臂內側，兩臂交叉合抱，左臂斜向上，右臂斜向下。目視左前下方（圖60）。

要點：

1、雲扇擺掌源于京劇雲手動作，應以轉腰、仰頭、挺胸、轉頭來帶動兩手雲擺，同時配合兩臂內旋。

2、劈扇時，開步向西偏北，身體轉向東南。

2. Bow stance chop fan: Turn body left, open right leg one step to the right, bend left leg and adopt side bow stance. Chop fan in right hand obliquely downwards to the left and front; draw left palm to inside of right arm, the arms crossed, the left arm obliquely upward, the right arm obliquely downward. Look to the lower left and front (Figure 60).

Key points:

1. The 'cloud hands swing fan' movement originates from the Peking Opera's cloud hand movement, in which turn waist, raise head, straighten chest, turn head all drive the 'cloud' swing of the hands, as they rotate inwards in harmony.

2. In the 'chop fan' form, step to the northwest, turn body to the southeast.

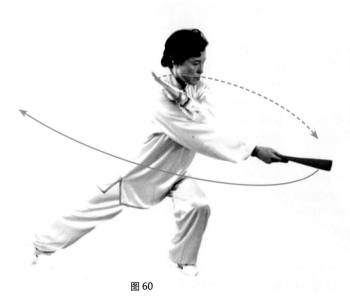

图 60

bà wáng jǔ qí (xiē bù liàng shàn)

（二十五）霸王舉旗（歇步亮扇）

(25) Overlord raises flag (rest stance flash fan)

1、轉腰擺扇：身體右轉，重心右移。右手握扇向下、向右擺至體側；左掌向上、向左劃弧分開。目視右側（圖61）。

2、歇步亮扇：身體左轉，左腳向右腿右后方插步，兩腿交疊屈蹲下坐，成歇步。右手直臂上舉側立開扇于頭側上方；左掌立掌收至右胸前，掌心向右。甩頭轉視左（東）側（圖62）。

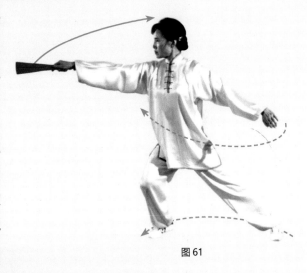

图61

要點：

1、亮扇與（三）白鶴亮翅相同，唯右臂在頭側直臂上舉。

2、歇步、亮扇、收掌、甩頭要協調一致。

(25) Overlord raises flag (rest stance flash fan)

1. Turn waist swing fan: Turn body right, shift weight right. Swing fan in right hand down and to the right beside body; separate left palm in an arc upwards and to the left. Look to the right (Figure 61).

2. Rest stance flash fan: Turn body left, pass left foot to the right behind right leg, squat down on folded legs, adopt rest stance. Raise right arm straight above side of head and open fan; bring left palm to front of right chest, palm upright and facing right. Flick head to look to the left (east) (Figure 62).

Key points:

1. 'Flash fan' is the same as (3) White crane flashes its wings, except the right arm is raised straight above the head.

2. Rest stance, flash fan and draw palm, flick head should be in harmony.

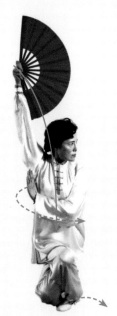

图62

bào shàn guò mén (kāi bù bào shàn)

（二十六）抱扇過門（開步抱扇）

(26) Embrace fan pass through doorway (open step embrace fan)

1、開扇托抱：身體起立，左腳向前上步，腳尖內扣，身體右轉成開立步。兩手托扇抱于腹前，手心皆向上，扇面與身體平行，方向朝南。目視前方（圖63）。

2、合扇舉抱：身體不動，兩手分開，順勢合扇，兩手經體側劃弧抱于體前，兩臂撐圓，扇頂向上。目視扇頂（圖64）。

要點：此動作爲過門連接動作，要求舒松自然，有間歇停頓。

(26) Embrace fan pass through doorway (open step embrace fan)

1. Open fan carry embrace: stand up, step left foot forwards, turn left toes inward, turn body right and adopt open stance. Hold fan in front of abdomen with both hands, palms up, fan surface parallel to body facing south. Look ahead (Figure 63).

2. Close fan lift encircle: Keep body still, separate hands, closing fan. Draw both hands in an arc from each side of body and encircle in front of body, both arms rounded, tip of fan pointing up. Look at tip of fan (Figure 64).

Key point: 'Pass through doorway' is a linking movement which requires a relaxed and natural posture and a brief pause.

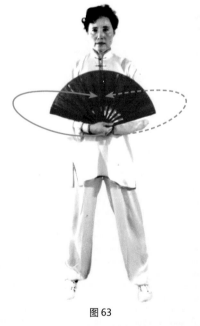

图63

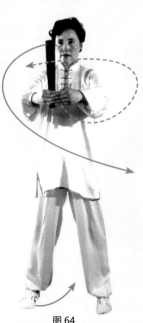

图64

第四段
Fourth section

yě mǎ fèn zōng (gōng bù xuē shàn)
（二十七）野馬分鬃（弓步削扇）

(27) Part the wild horse's mane (bow stance slice fan)

1、轉腰合臂：上體左轉，右脚提收至左踝内側，兩臂交叉合抱于左胸前。目視左下方（圖 65）。

2、弓步削扇：身體右轉，右脚向右邁出一步，重心前移，左腿蹬直，成右弓步。兩臂向右上方和左下方分開，成一直綫。右手高與頭平，手心斜向上；左手高與胯平，手心斜向下。目視右扇（圖 66）。

要點：

1、合臂、削扇都要以腰帶臂，腰肢協調一致。

2、此勢采自查拳動作，要求舒展挺拔，放長擊遠。弓步方向正西。

图 65

(27) Part the wild horse's mane (bow stance slice fan)

1. Turn waist close arms: turn upper body left, bring right foot to inside of left ankle, bring arms together and cross in front of left chest. Look left and downwards (Figure 65).

2. Bow stance slice fan: Turn body right, take a step to the right, shift weight forwards, thrust with left leg, adopt right bow stance. Separate arms to upper right and lower left to form a straight line. Right hand level at head height, palm facing up; left hand level at waist height, palm facing down. Look at fan (Figure 66).

Key points:

1. In the close arms, slice fan sequence, waist leads arms, the movements in harmony with the waist.

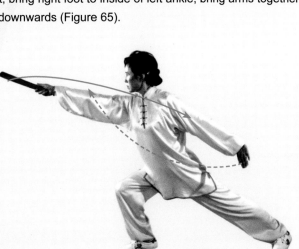

图 66

2. This form is taken from a Chaquan movement, which requires stretching tall and straight, and lengthening to strike farther. Bow stance is due west.

chú yàn líng kōng (bìng bù liàng shàn)

（二十八）雛燕凌空（并步亮扇）

(28) Young swallows soar in the sky
(closed stance flash fan)

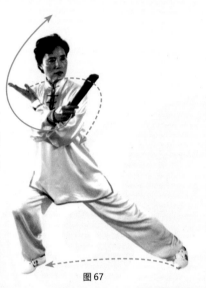

1、轉腰穿掌：重心不動，右腳尖內扣，身體左轉。右手握扇向左、向下劃弧至左肩前；左掌向右、向上經右臂內側穿出，兩臂在胸前交叉，掌心均向內；目視右手扇（圖67）。

(28) Young swallows soar in the sky (closed stance flash fan)

1. Turn waist cross palms: Keep weight centred, twist right toes inward, turn body left. Draw fan in right hand in an arc left and down past front of left shoulder; lpass left palm to the right and upwards to inside of right arm, crossing arms in front of chest, palms facing inwards. Look at right fan (Figure 67).

图 67

2、并步亮扇：身體先右轉再左轉，左腳收至右腳旁，兩腿直立，成并步。右手握扇向下、向右、向上劃弧，至頭右上方時抖腕側立開扇；左掌向上、向左、向下劃弧，抱拳收于左腰間。向左甩頭，目視左（東）側（圖68）。

要點：

1、此勢爲長拳動作，要求頂頭、挺胸、收腹，身體挺拔直立。

2、并步、抱拳、開扇、轉腰、甩頭，要協調一致，干脆有力。

3、亮扇方法同（三）白鶴亮翅，唯右手直臂上舉。

2. Parallel stance flash fan: turn body first right then left, draw left foot beside right foot, stand upright on both feet, adopt parallel stance. Draw fan in right hand in an arc downwards, right, and upwards. At upper right of head, flick wrist to open fan; draw left palm in an arc upwards, left, and downwards, form a fist and draw beside left waist. Flick head left, look left (east) (Figure 68).

Key points:

1. This form is a Changquan (Long Fist) movement, which requires head up, chest upright, abdomen taught, body straight and upright.

2. Parallel stance, form fist, open fan, turn waist, flick head must all be in harmony with clear expression of force.

3. The 'flash fan' technique is the same as (3) White crane flashes its wings, except the right hand is raised straight up.

图 68

huáng fēng rù dòng (jìn bù cì shàn)

（二十九）黃蜂入洞（進步刺扇）

(29) Yellow bee enters a cave (step forward and thrust fan)

1、擺掌上步：身體先右轉再左轉，左脚向左（正東）上步。右手翻掌合扇，向右、向下卷收到右腰間；左拳變掌，向左、向上、向右劃弧至右胸前。目視左（東）側（圖69）。

2、弓步直刺：上體左轉，右脚向前上步，左脚蹬直，成右弓步。右手握扇前刺，手心向上，與肩同高；左掌向左、向上劃弧繞至頭左上方，掌心向上。目視右扇（圖70）。

要點：

1、刺扇與弓步要協調一致。

2、動作要干脆利落，舒展有力。

(29) Yellow bee enters a cave (step forward and thrust fan)

1. Swing palm step forwards: Turn body first right then left, step left foot to the left (east). Flick right palm to close fan, roll to the right and down beside right waist; left fist becomes palm, draw in an arc to left, upwards, right, to front of right chest. Look to the left (east) (Figure 69).

2. Bow stance level stab: Turn upper body left, step right foot forwards, thrust left foot, adopt right bow stance. Stab fan in right hand forwards, palm facing up, shoulder height; draw left palm in an arc left and upwards to upper left of head, palm facing up. Look at fan (Figure 70).

Key points:

1. Stab fan and bow stance should in harmony.

2. Movements should be crisp and neat, the **stretch forceful**.

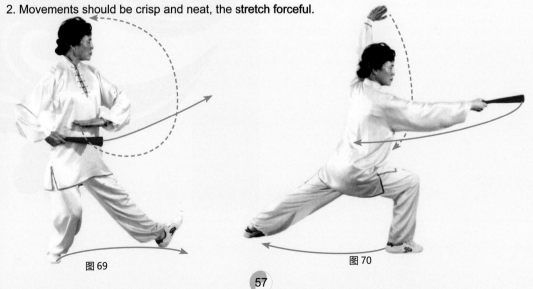

图69　　　　　图70

měng hǔ pū shí　(zhèn jiǎo tuī shàn)

(三十) 猛虎撲食 (震脚推扇)

(30) Fierce tiger pounces on prey (thud foot push fan)

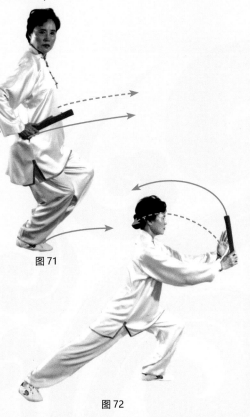

图 71

图 72

1、震脚收扇：重心后移，右脚收至左脚内側踏震落地；左脚迅速提起，靠近右踝内側。同時右手握扇收至右腰間，手心向左；左掌向下收于左腰間，手心向右；兩手貼緊身體，虎口斜向上。目視前方（圖71）。

2、弓步推扇：左脚向前上步，右腿蹬直，成左弓步。同時兩手向體前推出，左掌沿與右拳面朝前，手心相對，腕與肩同高；扇身竪直，目視前方（圖72）。

要點：

1、此勢爲長拳動作，要求快速有力，干脆利落。

2、震脚時，提脚高不過踝，踏落全脚着地，快速有力。兩脚換接緊密，不可跳躍。

(30) Fierce tiger pounces on prey (thud foot push fan)

1. Thud foot draw fan: shift weight backwards, draw right foot to inside of left foot and drop with a thud; lift left foot quickly and bring to inside of right ankle. At the same time, draw fan in right hand beside right waist, palm facing left; draw left palm down beside left waist, palm facing right; keep hands close to body, thumb and forefinger inclined upward. Look ahead (Figure 71).

2. Bow stance push fan: Step left foot forwards, thrust right leg, adopt left bow stance. At the same time, push both hands forwards, left palm-edge and right fist-face forwards, palms facing each other, wrists at shoulder height; the fan body is upright. Look ahead (Figure 72).

Key points:

1. This form is a Changquan (Long Fist) movement, which requires fast, crisp and neat expression of force.

2. In the 'thud foot' form, lift the foot higher than the ankle, drop the foot flat on the ground, fast and powerful. The two feet are equally balanced – do not jump.

táng láng bǔ chán (chuō jiǎo liáo shàn)

（三十一）螳螂捕蟬（戳脚撩扇）

(31) Praying mantis catching cicadas (heel kick flick fan inward)

1、轉腰繞扇：身體右轉，重心后移。右手内旋向上、向后劃弧繞扇；左掌附于右腕隨之劃弧。目視右手（圖73）。

2、分手繞扇：身體左轉，重心前移，左脚尖外撇。右手握扇繼續向下繞弧；左掌分開，向下、向左劃弧擺至肩高。目視左手（圖74）。

(31) Praying mantis catching cicadas (heel kick flick fan inward)

1. Turn waist spiral fan: turn body right, shift weight backwards. Rotate right hand inwards and draw in an arc spiraling upwards and backwards; place left palm on right wrist and then draw in an arc. Look at right hand (Figure 73).

2. Part hands spiral fan: turn body left, shift weight forwards, angle left toes outward. Continue circling fan in right hand downwards; swing left palm downwards and to the left then upwards to shoulder height. Look at left hand (Figure 74).

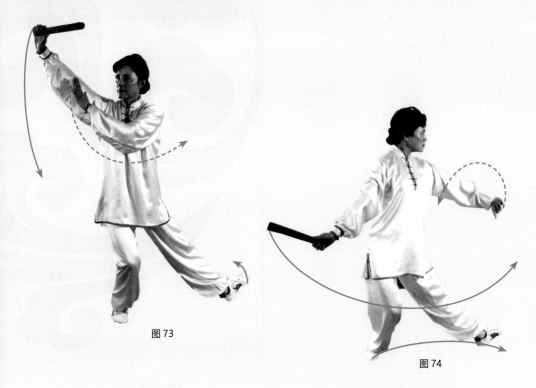

图73

图74

3、戳腳撩扇：上體左轉，右腳向前方戳踢，腳尖上翹，腳跟着地成右虛步。右手持扇向前下方撩起斜立開扇，手心斜向上；左掌收至右臂內側，掌心向右。目視扇沿（圖75）。

要點：

1、戳腳要求腳跟擦地，腳尖上翹，小腿向前擺踢。

2、開扇方向爲正東，扇骨與右臂平行斜向前下方，右手高與腹平；扇面斜立在右腿前上方。

3. Poke foot lift fan: Turn upper body left, poke and kick right foot forwards, toes tilted up, heel touches the ground in a right empty stance. Lift fan in right hand obliquely forwards and downwards to open fan, palm facing up; left palm drawn to inside of right arm, palm facing right. Look at fan edge (Figure 75).

Key points:

1. Poke foot requires heel to brush ground, toes up, kicking lower leg forwards.

2. The open fan points east, fan ribs parallel to right arm and obliquely forwards and downwards above right leg, right hand at level of abdomen.

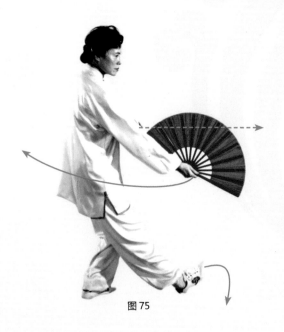

图75

lè mǎ huí tóu (gài bù àn shàn)

（三十二）勒馬回頭（蓋步按扇）

(32) Rein in horse to look back (cover stance press fan)

1、合扇轉身：身體右轉，右脚落實，脚尖外撇，左脚跟提起。同時右手持扇后抽；左掌前推合扇，兩臂向左右分開。目視右扇（圖 76）。

2、蓋步按扇：上體右后轉，左脚經右脚前向右蓋步，右脚跟提起。同時兩手向上、向內劃弧于頭前相合，再按至左腹前，左掌壓在右腕上。目視扇頂（圖 77）。

要點：

轉體蓋步要以腰爲軸，轉腰揮臂，提腿合胯，蓋步按扇，動作連貫銜接，協調配合。

(32) Rein in horse to look back (cover stance press fan)

1. Close fan turn around: turn body right, drop right forefoot, angle toes outward, lift left heel. At the same time, push left palm forwards and draw fan in right hand backwards through left palm closing fan, separate arms to left and right. Look at fan (Figure 76).

2. Cover stance press fan: turn upper body to the right and rear, cross left foot in front of right foot to the right in a cover step, lift right heel. At the same time, draw both hands in an arc upwards and inwards to meet in front of head, then press down to front of left abdomen, left palm on right wrist. Look at tip of fan (Figure 77).

Key points:

The 'turn body cover stance' form uses the waist as axis; turn waist, close hips; raise leg, cross step; spiral arms, press fan; should all be in harmony.

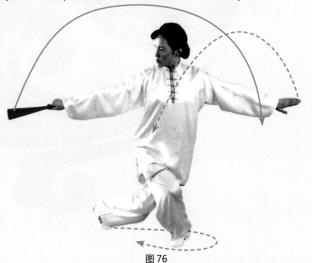

图 76

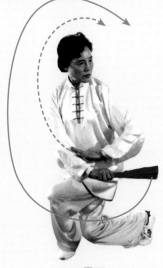

图 77

yào zǐ fān shēn (tuì bù cáng shàn)

（三十三）鷂子翻身（退步藏扇）

(33) Harrier turns over (step back, coil and hide fan)

1、翻身繞扇：以兩前腳掌碾地，上體挺胸展腹向右后翻轉。同時右手持扇隨轉體向上、向前繞擺至頭前上方，再以腕關節爲軸持扇挽一個腕花，使扇在右腕外側繞轉一周。左掌指仍扶于右腕部。目視右扇（圖 78）。

2、退步藏扇：右腳后退一步，左腿屈弓成左弓步；同時右手持扇向下、向后擺至身后；左手落經胸前，向前側立掌推出。目視左手（圖 79）。

要點：

1、翻身時，挺胸、仰頭、翻腰，以腰帶臂。

2、弓步推掌方向正東。

(33) Harrier turns over (step back, coil and hide fan)

1. Turn over spiral fan: Turn body to the right and rear on the balls of the feet, chest upright and abdomen taught. At the same time, swing fan in right hand upwards and forwards as the body turns, then with wrist as axis revolve fan in right hand around outside of right wrist. Keep left palm on right wrist. Look at right fan (Figure 78).

2. Step back hide fan: step right foot backwards, bend left leg and adopt left bow stance; at the same time, swing fan in right hand downwards and backwards behind back; drop left palm in front of chest and push out forwards with palm upright. Look at left hand (Figure 79).

Key points:

1. In the 'turn over' form, keep chest upright, raise head, turn waist, waist leads arms.

2. Bow stance push palm is due east.

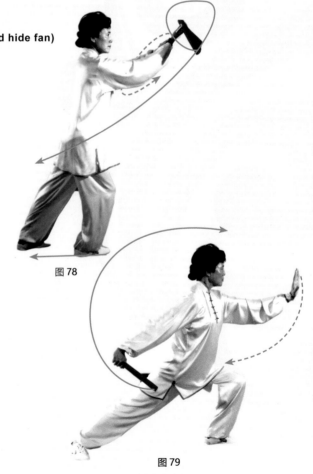

图 78

图 79

62

zuò mǎ guān huā (mǎ bù jī shàn)

（三十四）坐馬觀花（馬步擊扇）

(34) Sitting on a horse looking at flowers (horse stance flash fan)

1、返身穿扇：身體微左轉，右手持扇向上、向前掄至頭頂；左手沿體側向身後反手穿伸（圖80）。

身體迅速向右后轉，重心右移成右弓步。右手持扇沿體側向身後（西）反穿伸出；左手也隨之向左后（東）伸直。頭隨體轉，目視右扇（圖81）。

(34) Sitting on a horse looking at flowers (horse stance flash fan)

1. Turn body pierce fan: turn body slightly left, swing fan in right hand upwards and forwards to tip of head; pierce left hand across left ribs and extend behind body (Figure 80).

Quickly turn upper body to right and rear, shift weight right into a partial right bow stance. Pierce fan in right hand along side of body and stretch out to the right (west); extend left hand to the left (east). Turn head with body, look at fan (Figure 81).

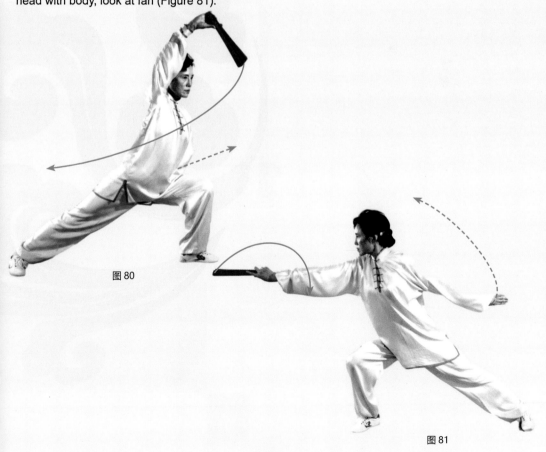

图 80

图 81

2、馬步擊扇：身體左轉，重心左移，成馬步。右手持扇翻轉，向左抖腕橫擊開扇，手心向內，與腰同高，停于右膝上方；左掌向上劃弧，舉于頭側上方，手心向上。目視扇沿（圖82）。

要點：

1、穿扇時扇頂領先，扇骨貼身，反手穿伸。

2、馬步擊扇時，兩腳平行；扇面朝向西南。

2. Horse stance strike fan: Turn body left, shift weight left, adopt horse stance. At the same time, flip right hand and flick wrist in a horizontal strike to open fan, palm facing inwards, at waist height, stopping above right knee; draw left palm in an arc upwards, lift above side of head, palm facing up. Look at fan edge (Figure 82).

Key points:

1. In the 'step back pierce fan' form, leading with tip of fan, the fan ribs pierce out along the side and behind the body.

2. In the 'horse stance strike fan' form, the feet are parallel, the fan faces southwest.

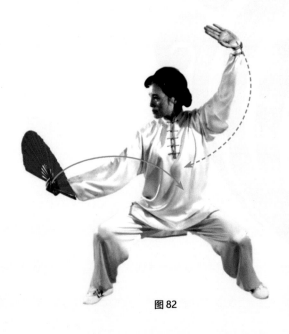

图82

第五段
Fifth section

shùn luán zhǒu (mǎ bù dǐng zhǒu)

（三十五）順鸞肘（馬步頂肘）

(35) Smooth elbow strike (horse stance elbow strike)

1、馬步合扇: 身體微左轉。右手左擺合扇收至胸前; 左掌同時落至胸前接握扇骨，扇頂斜向前上方。目視前（南）方（圖 83）。

2、馬步頂肘：兩腿沉胯，重心下降。兩臂屈肘，以肘尖爲力點向兩側后下方發勁頂擊。頭轉視右肘（圖 84）。

要點：

1、此勢采自陳式太極拳，頂肘發力要松快短促，兩拳屈收，貼近胸部。

2、頂肘后迅速放松，使兩臂産生反彈抖勁。

(35) Smooth elbow strike (horse stance elbow strike)

1. Horse stance close fan: Turn body slightly left. Swing right hand to the left to close fan and bring to front of chest; at the same time drop left palm to front of chest to hold base of fan, with tip of fan inclined forwards and upwards. Look ahead (south) (Figure 83).

2. Horse stance elbow strike: Sink hips and drop weight. Bend both elbows, strike back and down on each side with tips of elbows as point of force. Turn head to look at right elbow (Figure 84).

Key points:

1. This form is taken from Chen-style Taijiquan, the elbow strike should be rapid and brief, with both fists closed beside chest.

2. Relax immediately after the elbow strike so the arms generate a trembling recoil.

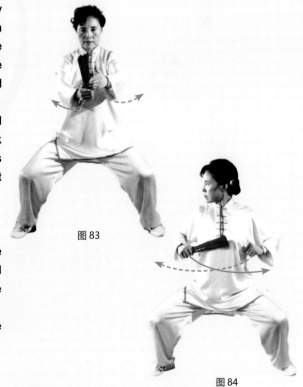

图 83

图 84

guǒ biān pào (mǎ bù zá quán)

（三十六）裹鞭炮（馬步砸拳）

(36) Wrapping firecrackers (horse stance and punch)

1、轉腰合臂：上體右轉，重心右移。兩臂于腹前交叉，左拳在外。眼看左拳（圖85）。

2、掄臂叠拳：上體左轉，重心左移，成馬步。左臂向上、向左掄擺一周；右臂稍向下伸，隨之依次輪擺一周，兩拳于腹前交叉相叠，右拳握扇壓在上面。目視前（南）方（圖86）。

(36) Wrapping firecrackers (horse stance and punch)

1. Turn waist close arms: Turn upper body right, shift weight right. Cross arms in front of abdomen, left fist outermost. Look at left fist (Figure 85).

2. Swing arms layer fists: Turn upper body left, shift weight left, adopt horse stance. Swing left arm upwards and to the left in a full circle; extend right arm slightly downwards, then swing in a full circle in turn, so the two fists cross one on top of the other in front of the abdomen, right fist holding fan on top. Look ahead (south) (Figure 86).

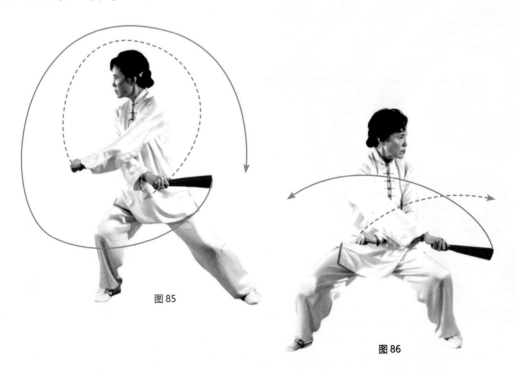

图85　　　　　　　图86

3、馬步翻砸：重心稍移向左腿成偏馬步。兩臂屈肘舉至胸前，小臂迅速翻展分開，抖彈發力，兩拳以拳背爲力點，向左右翻砸，拳與肩同高，拳心斜向上。目視左拳（圖87）。

要點：

1、此勢也是陳式太極拳發力動作。砸拳時要沉肩垂肘，氣沉丹田。

2、發力后兩拳松握制動，産生反彈抖勁。

3. Horse stance turnover strike: Shift weight slightly left and adopt left-biased horse stance. Bend elbows in front of chest, rapidly turn over and separate forearms, striking fists to left and right with a trembling force, fists at shoulder height, fist-hearts inclined upwards, point of force in backs of fists. Look at left fist (Figure 87).

Key points:

1. This is another powerful Chen-style Taijiquan movement. In 'strike fist', sink shoulders, drop elbows, and press energy (qi) into dantian.

2. After striking, release fists and stop, generating a trembling recoil.

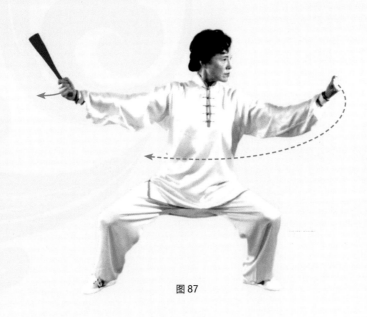

图 87

qián zhāo shì (xū bù bō shàn)

（三十七）前招勢（虛步撥扇）

(37) Forward sweep (Empty stance sweep with fan)

1、轉體擺掌：重心右移，身體右轉。左拳變掌內旋，向下、向右劃弧擺至右腹前；右手握扇內旋，向后伸展。目視右側（圖 88）。

2、虛步撥扇：身體左轉，左腳尖外撇，右腳向前（正東）上步，腳前掌點地，成右虛步。左掌向上、向左劃弧擺至頭左上方，指尖向右，掌心向上；右手握扇向下、向左撥扇，停于右膝前上方，掌心向左。目視前下方（圖 89）。

要點：

1、移動要平穩，步法要輕靈。

2、虛步的方向正東。

(37) Forward sweep (Empty stance sweep with fan)

1. Turn body swing palm: shifts weight right, turn body right. Left fist becomes palm, rotate inwards, swing in an arc downwards and right to front of right abdomen; rotate fan in right hand inwards and extend arm backwards. Look to the right (Figure 88).

2. Empty stance clip with fan: turn body left, angle left toes outward, step right foot forwards (due east), rest on forefoot and adopt empty stance. Swing left palm in an arc upwards and to the left to upper left of head, fingertips pointing to the right and palm facing up; clip fan in right hand downwards and to the left, stopping above right knee, palm facing left. Look forwards and downwards (Figure 89).

Key points:

1. The movement should be steady and footwork should be light.

2. The 'empty stance' is due east.

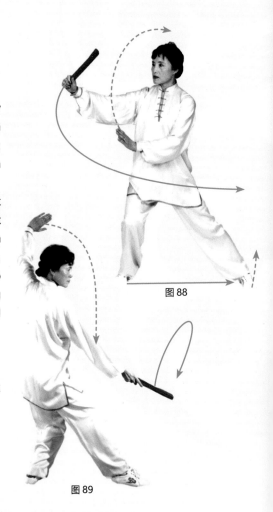

图 88

图 89

shuāng zhèn jiǎo (zhèn jiǎo pī shàn)

（三十八）雙震脚（震脚劈扇）

(38) Double foot stamp　(thud feet chop fan)

1、屈蹲分手：兩腿微屈，重心下降，上體稍前俯。右手握扇上舉，經頭前內旋，向右、向下劃弧；左掌下落至頭前，與右扇同時內旋，向左、向下劃弧，兩手對稱分開。目視前下方（圖90）。

(38) Double foot stamp　(thud feet chop fan)

1. Squat and separate hands: Slightly bend legs, lower weight, lean upper body slightly forwards. Lift fan in right hand, rotate inwards with tip pointing forwards, then draw in an arc to the right and down; drop left palm to front of head, rotate inwards at the same time as the right hand, then draw in an arc to the left and down, the two hands matching. Look forwards and downwards (Figure 90).

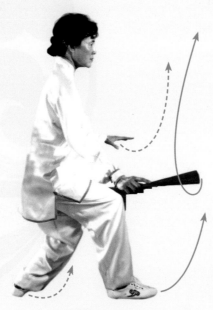

图90

2、蹬跳托扇：兩手外旋合收于腹前。隨之右腿屈膝上擺，左脚蹬地跳起，兩掌同時翻裹上托，右手稍高于肩，左掌在右肘內側。目視前方（圖91）。

3、震脚劈扇：左脚、右脚依次落地震踏。同時兩手內旋下劈，右手握扇劈于體前，與胸同高，扇頂向前；左掌在右肘內側劈壓，與腹同高，掌心均向下。目視右扇（圖92）。

要點：

1、本勢是陳式太極拳縱跳發力動作。

2、兩手上托與擺腿蹬跳要一致；身體躍起后左右脚依次下落，震踏地面兩響。

2. Thrust jump cup fan: Rotate both hands outwards and bring together in front of abdomen. Then bend and swing right knee upwards, thrust with left foot and jump up, lift palms at the same time, right hand slightly higher than shoulder, left palm to inside of right elbow. Look ahead (Figure 91).

3. Thud feet chop fan: left foot and right foot drop with a thud in turn. At the same time, rotate both hands inwards and chop downwards, fan in right hand in front of body, at chest level, tip of fan pointing forwards, left palm to inside of right elbow, level with abdomen, palms facing down. Look at fan (Figure 92).

Key points:

1. This is a powerful vertical jump movement from Chen-style Taijiquan.

2. Lift hands, swing leg, jump up should be done in unison; after jumping, left and right feet land in turn, striking the ground twice.

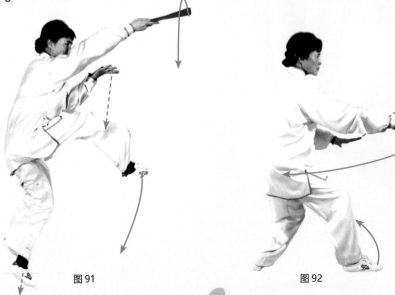

图91　　　　　　　图92

lóng hǔ xiàng jiāo (dēng jiǎo tuī shàn)

（三十九）龍虎相交（蹬脚推扇）

(39) Dragon and tiger cross paths (kick foot push fan)

1、提膝收扇：右腿屈膝上提，上體右轉。右手握扇收至右腰間；左掌經右手下向前穿出。目視前方（圖 93）。

2、蹬脚推扇：右脚以脚跟爲力點，快速向前蹬出。同時轉腰順肩，右手持扇前推，高與肩平，扇骨竪直向上；左掌架于頭側上方。目視前方（圖 94）。

要點：

1、蹬脚和推扇快速有力，同步完成，方向爲正東。

2、身體要正直、站穩。

(39) Dragon and tiger cross paths (kick foot push fan)

1. Raise knee draw fan: Bend and raise right knee, turn upper body right. Draw fan in right hand to right waist; pass left palm beneath right hand forwards. Look ahead (Figure 93).

2. Kick foot push fan: Quickly kick right foot forwards, with heel as force point. At the same time, turn waist followed by shoulders, and push fan right hand forwards, at shoulder height, fan upright; left palm supporting over side of head. Look ahead (Figure 94).

Key points:

1. Kick foot and push fan are quick and powerful, completed in synchrony, the direction is due east.

2. Keep body upright and stand firm.

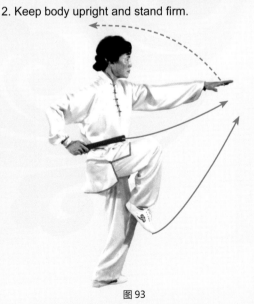

图 93

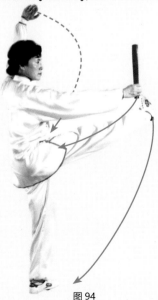

图 94

yù nǚ chuān suō (nǐng shēn liàng shàn)

（四十）玉女穿梭（擰身亮扇）

(40) Jade maiden works the shuttles (twist body flash fan)

1、落脚合臂：身體右轉，右脚前落，脚尖外撇，重心前移，左脚跟提起。同時，兩手落至腹前，腕部交叉，左掌在上。頭隨體轉。目視東南（圖95）。

2、插步展臂：身體繼續右轉，左脚扣脚上步，右脚經左脚后向左插步，重心移至左腿。兩臂分別向左、向右展開，腕同肩高。目視右扇（圖96）。

(40) Jade maiden works the shuttles (twist body flash fan)

1. Drop foot close arms: Turn body right, drop right foot forwards, angle toes outward, shift weight forwards, lift left heel. At the same time, drop hands to front of abdomen, cross wrists, left palm facing up. Turn head with body. Look to the southeast (Figure 95).

2. Cross step extend arms: Continue turning right, turn left foot inwards and step forwards, pass right foot to the left behind left foot in a cross step, shift weight onto left leg. Spread arms to either side, wrists at shoulder height. Look at right fan (Figure 96).

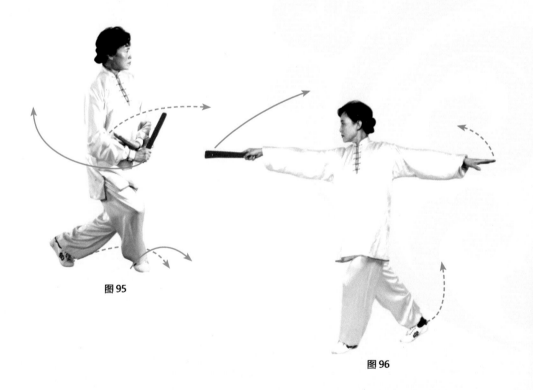

图95

图96

3、后舉腿亮扇：左腿支撐，右腿后舉，小腿屈收，脚面展平。同時上體擰腰左轉，右手握扇舉至頭側上方抖腕側立開扇；左掌舉至左側沉腕挑掌，掌心斜向外，與肩同高。目視左掌（正東）（圖97）。

要點：

1、上插步時速度要快，也可做成跳插步。

2、亮扇挑掌與后舉腿要協調一致。同時擰腰、挺胸、轉頭，右腿屈膝后舉，身體反弓，成望月平衡勢。扇骨保持竪直，扇面向南。

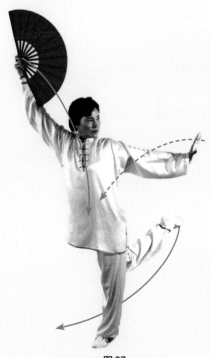

图97

3. Raise rear leg back flash fan: standing on left leg, raise right leg backwards, flexing calf and flattening foot. At the same time, twist upper body left at the waist; raise fan in right hand above head, flick wrist to open fan; raise left palm to the left, drop wrist and raise palm, palm facing obliquely outward at shoulder height. Look at left palm (due east) (Figure 97).

Key points:

1. The 'cross step' form should be fast and may also be done as a jump step.

2. Flash fan, raise palm, lift rear leg should all be in harmony. At the same time, twist waist, straighten chest, turn head, bend right knee to raise leg, arch body backwards, forming a balanced 'full moon' posture. Fan ribs are upright with the fan facing south.

tiān nǚ sàn huā　(yún shàn hé bào)

（四十一）天女散花（雲扇合抱）

(41) Heavenly maiden scatters flowers (cloud fan and embrace)

1、開步抱扇：身體轉向正南，右脚向右落步，兩脚平行，成開立步。右手握扇外旋下落，橫扇抱于胸前；左掌向下落于右手內側。目視前方（圖98）。

2、開步雲扇：兩腿不動。兩手經兩側分開劃弧舉至頭頂。右手旋臂轉腕，持扇在頭頂雲轉一周，左手在頭頂與右腕相合。目仰視右。扇（圖99）。

(41) Heavenly maiden scatters flowers (cloud fan and embrace)

1. Open stance embrace fan: Turn body south, step right foot to the right, feet parallel, adopt open stance. Turn fan in right hand outwards and drop downwards, bring fan horizontal and embrace in front of chest; drop left palm downwards to inside of right hand. Look ahead (Figure 98).

2. Open stance cloud fan: Do not move legs. Raise hands in an arc to either side and above head. Rotate right arm and turn wrist with fan in a full circle 'in the clouds' over top of head, bring left hand to right wrist over top of head. Look up at fan (Figure 99).

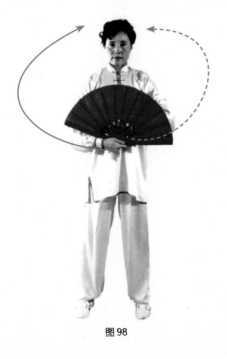

图98

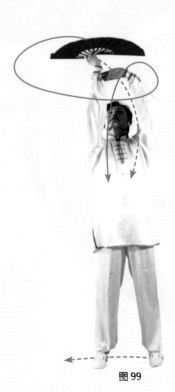

图99

3、插步抱扇：左脚經右脚后向右插步，重心與開立步同高，右手持扇下落，抱于懷中；左手隨之下落，附于右腕内側。目視前方（圖 100）。

要點：

1、抱扇高度以扇沿頂部不超過下頦爲宜。

2、雲扇時仰頭挺胸，腕指要靈活。扇面在頭上旋轉平雲，與（二十四）雲手擺扇不同。

3. Cross step embrace fan: Pass left foot to the left behind right foot in a cross step, but maintain weight at same height as open stance, drop fan in right hand and embrace over heart; then drop left hand to inner right wrist. Look ahead (Figure 100).

Key points:

1. In the 'embrace fan' form, the top of the edge of the fan should not be above the chin.

2. In the 'cloud fan' form, keep head up, chest upright, wrist relaxed. The fan rotates flat 'in the clouds' over the head, which is different from (24) Cloud hands swing fan.

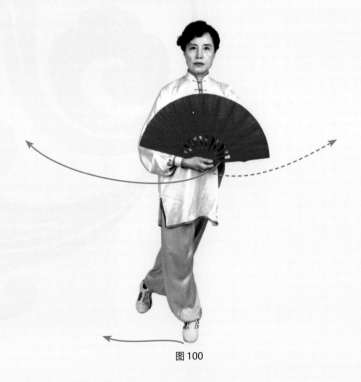

图100

bà wáng yáng qí (xiē bù liàng shàn(

（四十二）霸王揚旗（歇步亮扇）

(42) Overlord raises a flag (rest stance flash fan)

1、開步展臂：上體右轉，右脚向右開步，重心右移。兩手左右平展，順勢將扇合上，兩手心皆向下。目視右扇（圖101）。

2、歇步亮扇：左脚向右脚右後方插步，兩腿交叠屈膝全蹲，成歇步。右手直臂舉至頭側上方抖腕亮扇；左掌收至右胸前，指尖向上，掌心向右。頭轉視左側（東）方（圖102）。

要點：

1、歇步與亮扇、收掌、甩頭要協調一致。

2、扇骨上下竪直，扇面向南，胸向東南。

图 101

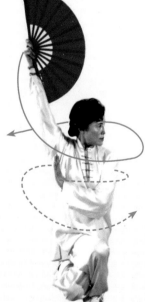

图 102

(42) Overlord raises a flag (rest stance flash fan)

1. Open step extend arm: Turn upper body right, step right foot to the right, shift weight right. Spread hands flat to either side, closing fan, both palms facing down. Look at fan (Figure 101).

2. Rest stance flash fan: Pass left foot to the right behind right foot, squat down on folded legs, adopt rest stance. Raise right arm straight above side of head, flick wrist to flash fan; bring left palm to front of right chest, fingertips pointing upwards, palm facing right. Flick head to the left (east) (picture 102).

Key points:

1. Rest stance, flash fan and draw palm, flick head should be in harmony.

2. The fan ribs point up and down, the surface of the fan faces south and the chest faces southeast.

háng bù guò mén (tuō shàn háng bù)

（四十三）行步過門（托扇行步）

(43) Embrace fan and pass through doorway (carry fan while walking)

1、轉身穿扇：兩腿伸直，腳掌碾轉，身體左后轉。右手持扇下落經胸前向左（西北）穿伸，扇沿領先，扇面水平，與肩同高；左手同時向外伸展，橫掌向外。目視右扇（圖 103）。

2、叉步托扇：右腳經左腳前向左蓋步，身體右轉，重心前移，左腳跟提起，成叉步。右手外旋屈收抱扇至胸前；左手亮掌舉于頭側上方。頭轉看右前（東北）方（圖104、附圖 104）。

(43) Embrace fan and pass through doorway (carry fan while walking)

1. Turn body pierce fan: straighten legs, twist on balls of feet, turn body to the left and backwards. Drop fan in right hand to front of chest and extend to the left (northwest), leading with edge of fan, surface of fan level, at shoulder height; at the same time, extend left hand outwards, palm facing outwards. Look at right fan (Figure 103).

2. Cross step carry fan: Pass right foot to the left in front of left in a cover step, turn body right, shift weight forwards, lift left heel, adopt cross stance. Rotate right hand outwards and bend to bring fan to front of chest; flash left palm and raise above side of head. Turn head and look ahead and right (northeast) (Figure 104).

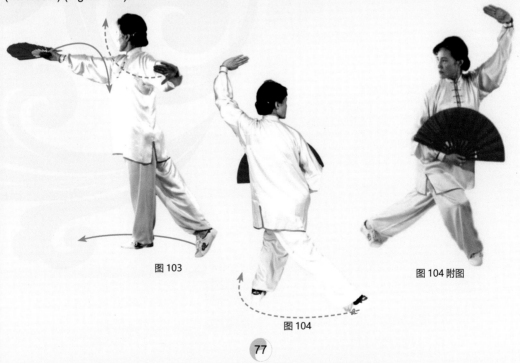

图 103

图 104

图 104 附图

3、托扇行步：上體保持不變，左腳沿弧綫行步。目視右側（圖105）。

4、托扇行步：上體不變，右腳沿弧綫行步。目視右側（圖106）。

5、抱扇行步：上體保持不變，左腳沿弧綫行步。目視右側（圖107）。

6、托扇行步：上體保持不變，右腳沿弧綫行步。目視右側（圖108）。

3. Carry fan while walking: keeping upper body unchanged, step left foot walking along an arc. Look to the right (Figure 105).

4. Carry fan while walking: keeping upper body unchanged, step right foot walking along an arc. Look to the right (Figure 106).

5. Carry fan while walking: keeping upper body unchanged, step left foot walking along an arc. Look to the right (Figure 107).

6. Carry fan while walking: keeping upper body unchanged, step right foot walking along an arc. Look to the right (Figure 108).

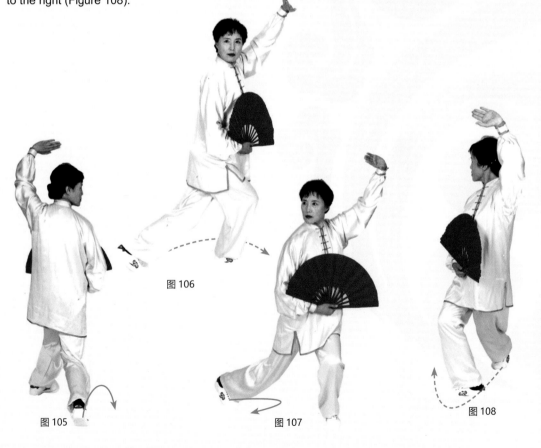

图 105　图 106　图 107　图 108

7、托扇行步：上體保持不變，左脚沿弧綫行步，至此行五步，路綫成一圓形，左脚在前，脚尖内扣，身體背向南，胸向北。頭轉看右前（東北）方（圖109）。

8、轉身合掌：左腿蹬地，右腿屈膝前提，以左脚掌爲軸碾轉，身體右后轉。右手抱扇位置不變；左手落于右腕内側。頭隨體轉，目視前方（圖110）。

7. Carry fan while walking: keeping upper body unchanged, step left foot walking along an arc. This fifth step completes the circle, with left foot in front, toes turned inwards, back to the south, chest to the north. Turn head and look ahead and to the right (northeast) (Figure 109).

8. Turn body close palms: Thrust with left leg, bend right knee. Spin with left foot as axis, turn body to the right and rear. Position of fan in right hand remains unchanged; drop left hand to inside of right wrist. Turn head with body and look ahead (Figure 110).

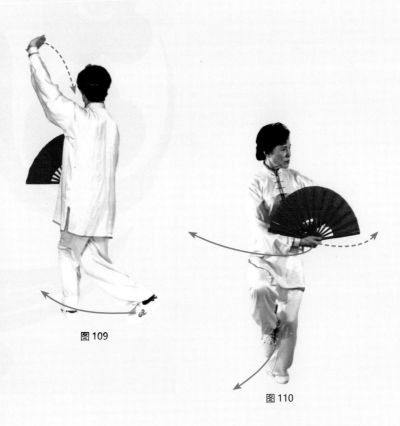

图 109

图 110

9、開步合扇: 右脚向右落地成開立步，身體轉向正南。兩手左右分開，順勢合扇，兩臂側平舉，手心向下。目視前方（圖 111）

要點：

1、本勢屬過門連接動作。開步合扇后，隨過門音樂稍稍停頓放松，准備開始第六段。

2、行步時要求重心平穩，起伏，不搖晃，脚跟先起先落，上體姿勢不變。

3、行步時按園弧切綫行進，第五步上步脚尖內扣，步幅稍小。

9. Open step close fan: Drop right foot to the right in an open step, turning body due south. Separate hands to left and right, closing fan, raise arms to horizontal, palms facing down. Look ahead (Figure 111).

Key points:

1. 'Pass through door' is a linking movement. After 'Open step close fan', pause and relax with the music for a moment, ready to start the sixth section.

2. When 'walking', keep center of gravity stable, rising and falling without shaking, lifting and dropping the heel first, while the upper body posture remains unchanged.

3. When 'walking', follow the tangent of the arc, and in the fifth step, twist toes inward and take a slightly smaller step.

图 111

第六段
Sixth section

qī xīng shǒu (xū bù bīng shàn)
（四十四）七星手（虛步掤扇）

(44) Seven-star hand (empty stance ward-off with fan)

1、兩臂前舉：兩臂慢慢向前平擺成前平舉，與肩同寬，肘、腕關節微屈，左指和右扇斜向前上方。目視前方（圖 112）。

2、屈膝按扇：兩腿屈膝半蹲。兩手同時下按至胯旁，兩肘微屈，手心向下，指尖和扇頂向前。目視前方（圖 113）。

(44) Seven-star hand (empty stance ward-off with fan)

1. Raise arms forward: Slowly swing arms level and forwards and lift, shoulder width apart, bend elbows and wrists slightly, left fingers and right fan pointing forwards and obliquely upwards. Look ahead (Figure 112).

2. Bend knees press fan: Bend knees and squat. Press both hands down beside hips at the same time, bend both elbows slightly, palms down, fingertips and tip of fan pointing forwards. Look ahead (Figure 113).

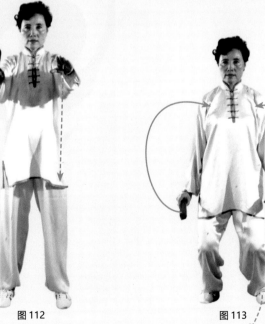

图 112　　　　　　图 113

3、虚步掤扇：左脚向前上步，脚跟着地，成左虚步。兩手經兩側向前上方劃弧　至體前，兩臂微屈。右手于右肩前抖腕開扇，扇沿向左，扇骨、扇面斜向上；左手附于右前臂内側，手心斜向下。目視扇面（圖114）。

要點：

1、此勢采自吴式太極拳。屈膝下蹲時要保持身體正直。

2、開扇與虚步同時完成。扇正面斜向下，小骨面斜向上。

3. Empty stance ward-off with fan: Step left foot forwards landing with heel, adopt left empty stance. Draw both hands in an arc forwards and upwards on either side to front of body, bend both arms slightly. Flick right hand in front of right shoulder to open fan, with fan edge to the left, fan ribs and fan face upright; bring left hand to inside of right forearm, palm facing down. Look at right fan (Figure 114).

Key points:

1. This form originates from Wu style Taiji. Keep body upright in the 'bend knees and squat' form.

2. Open fan, empty stance are completed at the same time. The smooth face of the fan is obliquely downwards, and the ribbed face obliquely upwards.

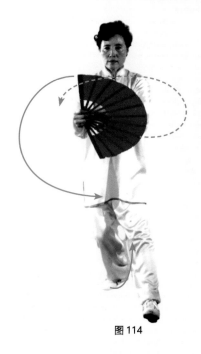

图114

lǎn zhā yī (gōng bù bīng shàn)

（四十五）攬扎衣（弓步掤扇）

(45) Tuck in robes (bow stance ward-off with fan)

1、收脚抱扇：左脚踏實，重心前移，右脚收至左脚內側。右手持扇向右、向下劃弧收至左腹前，扇面水平，扇沿向左；左掌向下、向左、向上劃弧收至左胸前，手心向下，两手上下相抱。目視左掌（圖115）。

(45) Tuck in robes (bow stance ward-off with fan)

1. Draw foot encircle fan: standing on left foot, shift weight forwards, draw right foot to inside of left foot. Draw fan in right hand in an arc to the right and down to front of left abdomen, surface of fan level, fan edge to the left. Draw left palm in an arc downwards, left, and upwards to front of left chest, palm facing down, upper and lower hands encircling. Look at left palm (Figure 115).

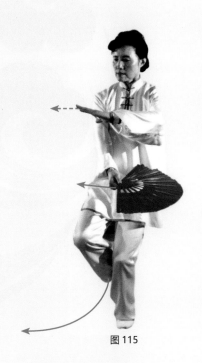

图 115

2、弓步掤扇：上體右轉，右脚向右前（西）方輕輕上步，脚跟着地（圖116）。

重心前移，左腿蹬直，成右弓步。同時右手向前持扇出，臂微屈，腕同肩高，扇小骨面斜向上；左掌向左向下按于左胯旁，掌心向下。目視扇面（圖117）。

要點：

1、本勢采自楊式太極拳。步法要輕靈平穩，身法要中正安舒。

2、轉身上步時，要注意與轉腰協調配合。

3、弓步時，左脚跟隨之蹬轉。

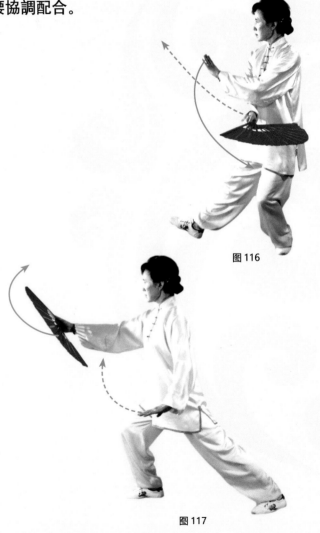

图116

2. Bow stance ward-off with fan: Turn upper body right, gently step right foot forwards (east) landing with heel (Figure 116).
Shift weight forwards, thrust left leg straight, adopt right bow stance. At the same time, lift fan in right hand out to the front, arm slightly bent, wrist at shoulder height, ribbed surface of fan obliquely upwards; press left palm to the left and down beside left hip, palm facing down. Look at fan (Figure 117).

Key points:

1. This form is taken from Yang-style Taiji. Footwork should be light and steady, and the body centred and serene.
2. Ensure turn body, step forward follow turn waist.
3. In the 'bow stance' form, turn heel when thrusting left leg.

图117

lǚ jǐ shì (hòu lǚ qián jǐ)
（四十六）捋擠勢（后捋前擠）

(46) Pull back and press (pull back, press forwards)

1、合手翻扇：上體微右轉。右手持扇前伸，手心翻轉向下；左掌翻轉前擺，停于前臂內下方，手心向上。目視前方（圖118）。

2、坐腿后捋：重心后移，左腿屈坐，上體左轉。兩手同時向下、向后劃弧后捋。左手擺至側后方，與頭同高，掌心斜向上；右手持扇擺至左胸前，手心向內，扇面與身體平行。目視左手（圖119）。

(46) Pull back and press (pull back, press forwards)

1. Close hands turn fan: Turn upper body slightly right. Extend fan in right hand forwards, turn palm to face down; turn left palm to face up and swing forward, stopping at inner lower forearm. Look ahead (Figure 118).

2. Sit back and deflect: Shift weight backwards, sit back with left leg bent, turn upper body left. Draw both hands in an arc downwards and backwards together to deflect behind. Swing left hand to the side and backwards, level with head, palm facing up; swing fan in right hand to front of left chest, palm facing inwards, fan surface parallel to body. Look at left hand (Figure 119).

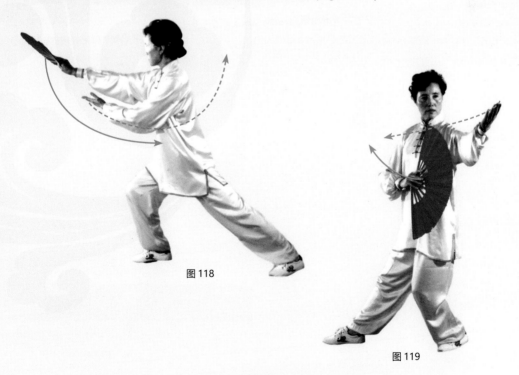

图118

图119

3、轉身搭手：身體右轉，朝向正西。兩手屈肘合于胸前，右掌心向內，扇骨、扇面豎立，扇沿向左；左掌心向外，掌指附于右腕內側。目視前方（圖120）。

4、弓步前擠：重心前移成右弓步，兩掌同時向前擠出，兩臂撐圓，扇骨保持豎立，扇沿向左。目視前方（圖121）。

要點：

1、此勢也爲楊式太極拳動作，應保持動作柔和自然，上下相隨，綿綿不斷。

2、后坐前弓時后脚不可扭動。后捋前擠應與腰部旋轉相配合。

3. Turn body join hands: Turn body right, facing west. Bring hands together in front of chest, elbows bent, right palm facing inwards, fan ribs and fan surface upright, fan edge to the left; left palm facing outwards, fingers on inner right wrist. Look ahead (Figure 120).

4. Bow stance press forwards: Shift weight forwards, adopt right bow stance, press both palms forwards together, the arms forming a circle, fan ribs upright, fan edge to the left. Look ahead (Figure 121).

Key points:

1. This form is also a Yang-style Taijiquan movement, soft and natural, continuous and unbroken.

2. Do not twist rear foot in the 'sit back, forward bow stance' form. Deflect behind, press forwards follow turn waist.

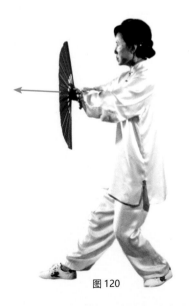

图 120

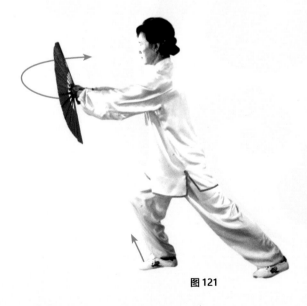

图 121

sū qín bèi jiàn (bìng bù bèi shàn)

(四十七) 蘇秦背劍 (并步背扇)

(47) Su Qin holds sword behind back (close stance fan behind back)

1、后坐平雲：重心后移，上體右轉，左腿屈坐，右脚尖上翹，右手持扇翻轉使扇面向上，自前向右、向后平雲至體側；左掌仍附于右腕內側隨之劃弧。目視扇面 (圖122)。

2、轉腰推扇：身體左轉，右脚尖內扣。右臂內旋屈收，右腕仰翹，右手持扇側立，向左劃弧推出，扇面轉向南；左掌仍附于右腕內側，掌心轉向上。目視左前 (南) 方 (圖123)。

(47) Su Qin holds sword behind back (close stance fan behind back)

1. Sit back level cloud fan: shift weight backwards, turn upper body right, sit back with left leg bent, tip right toes up, turn fan in right hand so the fan faces upwards, then draw in an arc level 'in the clouds' from front to right and rear, keeping left palm on inner right wrist. Look at fan (Figure 122).

2. Turn waist push fan: turn body left, twist right toes inwards. Rotate right arm inwards and bend elbow, tilt right wrist up, fan in right hand upright, draw in an arc and push out to the left, turning face of fan to the south; keep left palm on inner right wrist, palm turning upwards. Look to the left and ahead (south) (Figure 123).

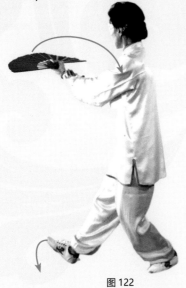

图 122

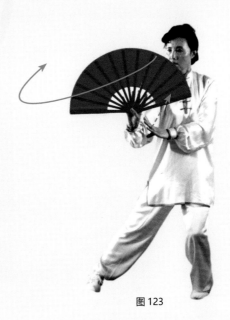

图 123

3、并步背扇：身體右轉，重心右移。右手持扇内旋向右劃弧，伸臂擺至體側，虎口向下；左掌收于右胸前。目視右扇（圖124）。

左脚向右脚并步，兩腿直立，身體左轉，胸向正南。右手持扇擺向身后，扇骨面貼于背后；左掌側立掌向左前方（東南）推出，腕與肩平，掌心斜向前。目視左掌（圖125）。

要點：

1、平雲扇要隨腰的轉動向右平圓劃弧；上體保持松正，右臂先伸展后屈收。

2、并步、背扇與推掌要協調一致。并步方向正南；推掌方向東南。

3. Parallel stance fan behind back: turn body right, shift weight right. Draw fan in right hand in an arc to the right, extend arm along side of body, thumb and forefinger pointing downwards; bring left palm to front of right chest. Look at fan (Figure 124).

Bring left foot to right foot in a parallel stance, legs upright, turn body left, chest facing south. Swing fan in right hand behind back, ribbed surface close to back; push left palm out to the left and front (southeast), wrist shoulder level, palm facing obliquely forwards. Look at left palm (Figure 125).

Key points:

1. 'Level cloud-fan' should follow the rotation of the waist arcing to the right in a flat circle.

2. Parallel stance, fan behind back and push palm should all be in harmony. The parallel stance is due south; push palm is to the southeast.

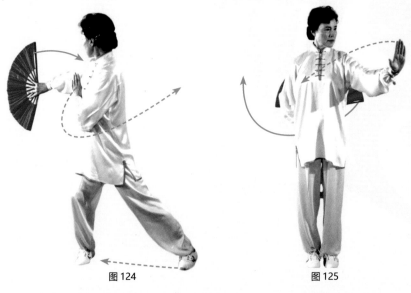

图 124　　　　　　　　　图 125

lǒu xī niù bù　　(gōng bù chuō shàn)

（四十八）摟膝拗步（弓步戳扇）

(48) Brush knee twist stance (bow stance thrust fan)

1、擺掌合扇：身體右轉。左掌經頭前向右劃弧落至右肩前，手心向右；右手握扇自背后伸向右前方，腕同肩高，扇沿向下；隨之右腕翻轉合扇，手心轉向上。目視右扇（圖 126）。

(48) Brush knee twist stance (bow stance thrust fan)

1. Swing palm close fan: Turn body right. Draw left palm in an arc to the right in front of head and drop to front of right shoulder, palm facing right; extend fan in right hand from the back to the right and front, wrist at shoulder height, fan edge pointing downwards; then rotate right wrist to close fan, turning palm upwards. Look at right fan (Figure 126).

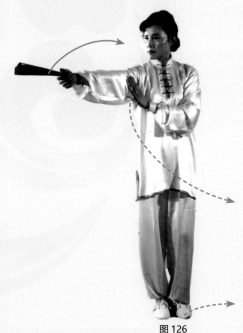

图 126

2、轉身上步：上體左轉，左脚向前（東）方邁出一步，脚跟輕輕落地。右臂屈肘，右手握扇收至頭側，扇根朝前；左手落在腹前。目視前方（圖 127）。

3、弓步戳扇：上體繼續左轉，重心前移，成左弓步。右手以扇根爲力點向前戳出，高與頭平；左手摟至左胯旁，掌心向下。目視前方（圖 128）。

要點：

1、拗弓步時，爲保重心穩定，兩脚左右寬度要保持 30 厘米左右。

2、戳扇時扇根朝前，扇骨水平。前戳、下摟和弓腿同時到位。

2. Turn body step forwards: Turn upper body left, step left foot forwards (east), landing lightly with heel. Bend right elbow, draw fan in right hand beside head, fan base facing forwards; drop left hand to front of abdomen. Look ahead (Figure 127).

3. Bow stance poke fan: Continue turning left, shift weight forwards, adopt left bow stance. Poke base of fan forwards with right hand, at head level; sweep left hand down to left hip, palm facing down. Look ahead (Figure 128).

Key points:

1. In the 'oblique stance' form, in order to maintain stability, keep your feet about 30cm apart.

2. In the 'poke fan' form, base of fan points forwards and fan ribs are level. Poke forwards, sweep down, bow stance are all done at the same time.

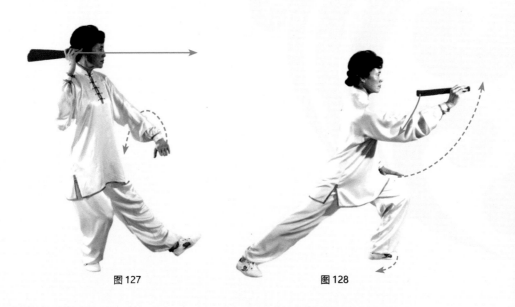

图 127　　　　　　　　　图 128

dān biān xià shì　(pú bù chuān shàn)

（四十九）單鞭下勢（僕步穿扇）

(49) Low single whip (crouch stance thread fan)

1、轉身勾手：身體右轉，左腳尖内扣，右脚向后輕輕移動半步。左手變勾手提至身體左側，與頭同高；右手握扇屈收至左肩前，扇根向左，扇頂向右。目視左勾手（圖 129）。

2、僕步穿扇：左腿全蹲，右腿伸直，上體右轉，成右僕步。右手握扇下落順右腿内側向右穿出，伸至踝關節内側時，旋臂抖腕平立開扇。目視扇沿（圖 130）。

要點：

1、轉身勾手時重心仍在左脚。

2、僕步開扇后扇骨與地面平行，扇面朝南，立于右腿内側。

(49) Low single whip (crouch stance thread fan)

1. Turn body hook hand: Turn body right, twist left toes inward, lightly shift right foot back half a step. Left hand becomes hook to the side at head height; bring fan in right hand to left shoulder, base to the left and tip to the right. Look at left hook (Figure 129).

2. Drop stance pierce fan: Squat fully on left leg, straighten right leg, turn upper body right, adopt right drop stance. Pierce fan in right hand to the right out along inside of right leg. On reaching inside of ankle, turn arm and flick wrist to open fan. Look at fan edge (Figure 130).

Key points:

1. Keep weight on left foot in the 'turn body, hook hand' form.

2. After drop stance, open fan, fan ribs are parallel to the ground, fan surface faces south, upright on inner right leg.

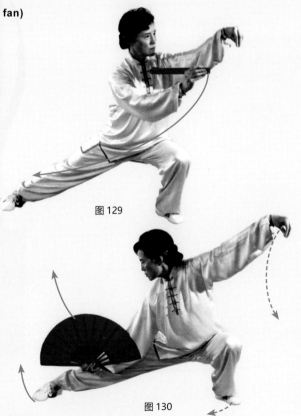

图 129

图 130

wǎn gōng shè hǔ (gōng bù jià shàn)

（五十）挽弓射虎（弓步架扇）

(50) Drawing a bow to shoot the tiger (bow stance lift up fan)

1、弓腿起身：重心前移，上體右轉，右脚尖外展，左脚尖内扣，右腿屈弓，成右弓步。右手托扇上舉與肩平；左臂内旋背于身后，勾尖向上。目視前方（圖 131）。

2、轉腰擺臂：上體右轉。右手握扇向下、向右劃弧擺至身體右側，旋臂翻腕手心向上；左勾手變拳向上、向前劃弧擺至右肩前，拳心向下。目視右扇（圖 132）。

(50) Drawing a bow to shoot the tiger (bow stance lift up fan)

1. Rise into bow stance: shift weight forwards, turn upper body right, turn right toes outward, twist left toes inward, bend right knee, adopt right bow stance. Lift fan in right hand to shoulder level; rotate left arm inwards behind back, hook tip pointing up. Look ahead (Figure 131).

2. Turn waist swing arm: Turn upper body right. Swing fan in right hand in an arc downwards to the right of the body, spiral arm and turn palm to face upwards; left hook becomes fist, swing in an arc forwards to front of right shoulder, fist-heart downwards. Look at right fan (Figure 132).

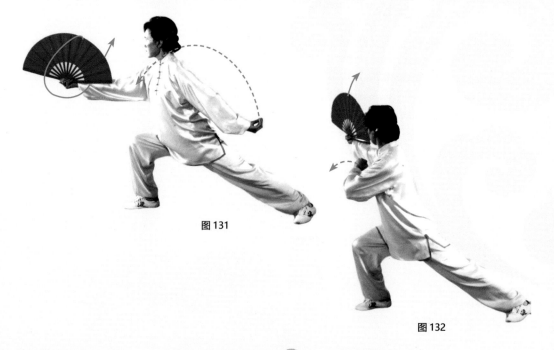

图 131

图 132

3、弓步架扇：上體左轉。右手握扇屈收至肩部上架，舉至頭側上方，右臂微屈，手略高于頭；左拳經胸前向左前（南）方打出，高與肩平，拳面斜向前，拳眼斜向下。目視左拳（圖133）。

要點：

1、轉腰與擺臂要協調一致。

2、定勢時，弓步方向爲正西，上體半面左轉，衝拳方向正南；架扇扇沿向上，扇骨水平，扇面朝南。

3. Bow stance support fan: Turn upper body left. Bend right arm at shoulder level, raise fan in right hand above head, arm slightly bent, hand slightly higher than head; punch left fist from front of chest to the left and front (south), at shoulder level, fist-face obliquely forwards, fist-eye obliquely downwards. Look at left fist (Figure 133).

ey points:

1. Turn waist and swing arm should be in harmony.

2. In setting this posture, bow stance is to the west, upper body turns left, punch is to the south; the fan is upright, fan ribs horizontal, fan surface faces south.

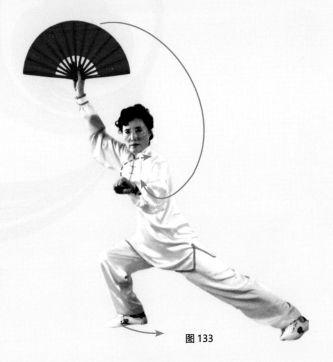

图133

bái hè liàng qiào (xū bù liàng shàn)

（五十一）白鶴亮翅（虛步亮扇）

(51) White crane flashes wings (empty stance flash fan)

1、轉腰合扇：身體左轉，重心左移，右脚內扣。右手握扇外旋下落，經體前收至胸前；左拳變掌屈收胸前，再推至體前，與右腕交錯時順勢合扇。目視前方（圖134）。

2、轉腰分手：身體右轉，重心右移。右手握扇向下、向右劃弧，擺至右胯側；左掌向上、向左劃弧，擺至頭左側。目視右前方（圖135）。

(51) White crane flashes wings (empty stance flash fan)

1. Turn waist close fan: turn body left, shift weight left, turn right toes inward. Turn fan in right hand outwards, drop across front of body to front of chest; left fist becomes palm, bend arm to bring palm to front of chest, then push out to front of body, closing fan as it passes over right wrist. Look ahead (Figure 134).

2. Turn waist separate hands: Turn body right, shift weight right. Swing fan in right hand in an arc downwards and to the right beside right hip; swing left palm in an arc upwards to the left of head. Look ahead and right (Figure 135).

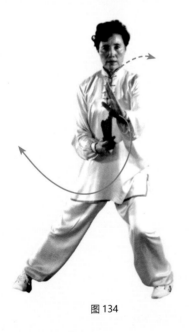

图 134

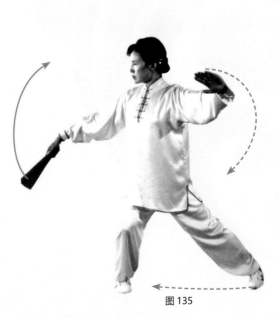

图 135

3、虛步亮扇：身體轉正，左腳向前上步，腳前掌着地，成左虛步。兩手繼續向左下和右上方劃弧，左掌按在左胯旁；右手在頭右前方抖腕側立開扇。目視前方（圖136）。

要點：

1、重心移動、轉腰、兩臂揮擺要協調配合，行動一致。

2、虛步與亮扇要同時完成。扇骨上下竪直，扇正面（光滑面）朝前，背面（小扇骨面）朝后，扇沿向左。

3、本勢采自楊式太極拳，要求中正安舒。

3. Empty stance flash fan: Turn body right, step left foot forwards, rest on forefoot, adopt left empty stance. Continue to draw hands in an arc to lower left and upper right, pressing left palm down beside left hip; bring right hand to upper right front of head, flick wrist sideways to open fan. Look ahead (Figure 136).

Key points:

1. Shift weight, turn waist, swing arms should all be in harmony and in unison.

2. Empty stance and flash fan should be completed at the same time. The fan ribs are upright up and down, the smooth front of the fan forwards, the ribbed back of the fan backwards, the edge of the fan to the left.

3. This form is taken from Yang-style Taijiquan, which is centred and serene.

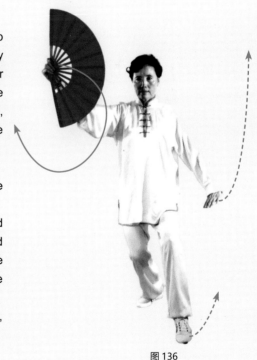

图 136

shōu shì (bào shàn hái yuán)

（五十二）收勢（抱扇還原）

(52) Closing form (encircle with fan and return to origin)

1、開步平舉：身體慢慢站立，左脚撤回與右脚成開立步。右手翻腕合扇，落經腰間再向右平舉，扇頂向右；左臂同時向左平舉，兩手心皆向下。目視前方（圖 137）。

(52) Closing form (encircle with fan and return to origin)

1. Open step hold level: Slowly rise, draw left foot beside right foot, adopt open stance. Flick right wrist to close fan, drop beside waist, then lift level to the right, tip of fan pointing to the right; at the same time raise left arm to the left, both palms facing down. Look ahead (Figure 137).

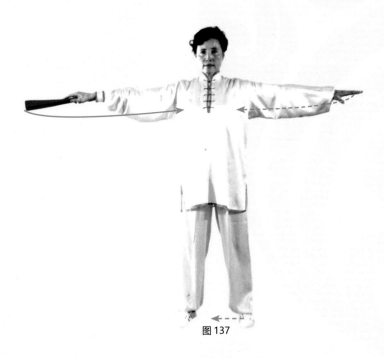

图 137

2、并步抱扇：左脚收至右脚内侧并步。兩手同時從兩側向前劃弧合抱于胸前，與肩同高，兩臂撐圓，左手在外，扇頂向上。目視前方（圖 138）。

3、垂臂還原：兩臂自然下垂至體側，身體還原成預備勢。目視前方（圖 139）。

要點：

1、開步平舉時，右手先合扇，再收脚展臂平舉。

2、并步與抱扇要同時。

2. Parallel stance encircle with fan: Bring left foot to inside of right foot in a parallel stance. At the same time, draw hands together in an arc from either side and encircle in front of chest, at shoulder height, arms rounded, left hand outermost, tip of fan pointing up. Look ahead (Figure 138).

3. Arms fall and restore: Allow arms to fall naturally to side of body, as body returns to preparatory position. Look ahead (Figure 139).

Key points:

1. In the 'open step, hold level' form, close fan in right hand first, then draw feet together and raise arms.

2. Parallel stance and encircle with fan should be done at the same time.

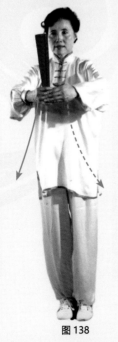

图 138　　　　图 139

太極功夫扇配樂介紹

配樂歌曲《中國功夫》

THE "TAIJI KONGFU FAN" SONG - CHINESE KUNG FU

屠洪剛原唱

宋小明 詞
伍嘉翼 曲

(Slow, solo)

6 · i | 5 6 | i 7 | 6 − − − | 6 · i | 5 6 | 4 5 |

Wǒ sì yī zhāng gōng, Zhàn sì yī kē
1. 卧 似 一 張 弓， 站 似 一 棵
Bending like a bow Standing like a

Nán quán hé běi tuǐ, Shǎo lín Wǔ dāng
2. 南 拳 和 北 腿， 少 林 武 當
Punching south, kick north Shaolin, Wudang's

Dōng fāng yī tiáo lóng, Ér nǚ sì yīng
3. 東 方 一 條 龍， 兒 女 似 英
Heroes boys and girls Dragons of the East

5/č 3 · · (0 3 3 · 2 1 2) | 3 | 3 2 | 5 5 6 | 3 4 | 3 2 1 | 1 − |

sōng, Bù dòng bù yáo zuò rú zhōng,
松， 不 動 不 搖 坐 如 鐘，
pine Calmly sitting like a bell

gōng, Tài jí Bā guà Lián huán zhǎng,
功， 太 極 八 卦 連 環 掌，
forms Taiji, Bagua, Linking Palms

xióng, Tiān gāo dì yuǎn bā miàn fēng,
雄， 天 高 地 遠 八 面 風，
Wide will spread, and high and far

1.3.
2 · 3 | 5 6 | 1 7 | 6 · · | (5 6 | 1 · 2 5 7 :|

Zǒu lù yī zhèn fēng.
走 路 一 陣 風。
Walking like the wind.

2.
2 · 3 | 5 6 | i 7 |

Zhōng huá yǒu shén
中 華 有 神
China's martial arts!

6 − − − ‖: 6 · i | 5 3 | 6 0 | 6 · i | 5 4 | 3 0 |

gōng, Wǒ sì yī zhāng gōng Zhàn sì yī kē sōng,
功， 卧 似 一 張 弓 站 似 一 棵 松，
Bending like a bow Standing like a pine

Wǒ sì yī zhāng gōng Zhàn sì yī kē sōng,
卧 似 一 張 弓 站 似 一 棵 松，
Bending like a bow Standing like a pine

3 · 2 | 5 6 | 3 2 1 | 2 · 3 | 5 6 1 7 | 6 0 | 6 · i | 5 3 | 6 0 |

Bù dòng bù yáo zuò rú zhōng, Zǒu lù yī zhèn fēng; Nán quán hé běi tuǐ,
不 動 不 搖 坐 如 鐘， 走 路 一 陣 風； 南 拳 和 北 腿，
Calmly sitting like a bell Walking like the wind Punching south, kick north

98

Bù dòng bù yáo zuò rú zhōng　Zǒu lù yī zhèn fēng；　Nán quán hé běi tuǐ，
不動 不搖 坐 如 鐘，　走 路 一 陣 風；　南拳 和 北 腿，
Calmly sitting like a bell　Walking like the wind　Punching south, kick north

6 · 1　5 4 3 0 ｜ 3 · 2　5 6 3 2 1 ｜ 2 · 3　5 6 7 6 — ‖

Shǎo lín Wǔ dāng gōng　Tài jí Bā guà Lián huán zhǎng　Zhōng huá yǒu shén gōng。
少 林 武 當 功，　太極 八卦 連 環 掌，　中 華 有 神 功。
Shaolin, Wudang's forms　Taiji, Bagua, Linking Palms　China's martial arts!

Shǎo lín Wǔ dāng gōng　Tài jí Bā guà Lián huán zhǎng　Zhōng huá yǒu shén gōng。
少 林 武 當 功，　太極 八卦 連 環 掌，　中 華 有 神 功。
Shaolin, Wudang's forms　Taiji, Bagua, Linking Palms　China's martial arts!

X X X X X 0 ｜ X X X X X 0 ｜ X̂X̂X X X X X ｜

Gùn sǎo yī dà piàn (hu!)　Qiāng tiǎo yī tiáo xiàn (ha!)　Shēn qīng hǎo sì yún zhōng yàn
棍 掃 一 大 片，　槍 挑 一 條 綫，　身 輕 好 似 雲 中 燕
Staves sweep, cut a swathe　Spears, banked, hold the line.　Bodies fly with swallow's ease,v

Qīng fēng jiàn zài shǒu (hu!)　Shuāng dāo jiù kàn zǒu (ha!)　Háng jia gōng fu yī chū shǒu
清 風 劍 在 手，　雙 刀 就 看 走，　行 家 功 夫 一 出 手，
Doubled swords in hand　Masters move like wind　Single moves enough to show

X X X X X 0 ｜ X X X X X 0 ｜ X̂X̂X X X X 0 ｜

Háo qiì chōng yún tiān (ha!)　Wài liàn jīn gǔ pí (pi!)　Nèi liàn yī kǒu qì (qi!)
豪 氣 衝 雲 天。　外 練 筋 骨 皮，　內 練 一 口 氣，
Valour brightens clouds,　Outward, strength is trained,　Inward, qi is groomed.

jiù zhī yǒu méi yǒu (you!)　Shǒu shì liǎng shàn mén (men!)　Jiǎo xià shì yī tiáo gēn (gen!)
就 知 有 沒 有。　手 是 兩 扇 門，　腳 下 是 一 條 根，
They have earned the right to fight.　Hands cleave, show new ways,　While rooted feet stand firm.

X X X X X X X X X ｜ X X X X X 0 ｜ （間奏略） ：‖

D.C.

Gāng róu bìng jì bù dī tóu Wǒ men xīn zhōng yǒu tiān dì (di!)
剛 柔 并 濟 不 低 頭 我 們 心 中 有 天 地。
Strong but agile, heads unbowed　In our hearts encompassed all!

Sì fāng shuǐ tǔ yǎng yù le Wǒ men Zhōnghuá wǔ shù hún (hun!)
四 方 水 土 養 育 了 我 們 中 華 武 術 魂
le China's rivers, earth and sky　Form our martial soul!

4. rit.

2 · 3　5 6　i 7 ｜ 6 — — ｜ 6 — — ｜ 6 0 0 0 ：‖

Zhōng huá yǒu shén gōng
中 華 有 神 功 。
China's martial arts!

Fine

99

動作與歌詞配合對照表
Movement and lyric synchrinisation guide

動作名稱 Movement	拼音 Pinyin	歌詞 Lyric	拼音 Pinyin	節拍 Beat
預備勢				
第一段（慢板）每分鐘 66 拍		**（音樂前奏）**		
（1）起　　勢	qǐ shì			
（2）斜飛勢	xié fēi shì	臥似一張弓	Wò sì yī zhāng gōng	八拍
（3）白鶴亮翅	bái hè liàng chì	站似一棵松	Zhàn sì yī kē sōng	八拍
（4）黃蜂入洞	huáng fēng rù dòng	不動不搖坐如鐘	Bù dòng bù yáo zuò rú zhōng	八拍
（5）哪吒探海	nǎ zhà tàn hǎi	走路一陣風	zǒu lù yī zhèn fēng	八拍
（6）金鷄獨立	jīn jī dú lì	南拳和北腿	nán quán hé běi tuǐ	八拍
（7）力劈華山	lì pī huá shān	少林武當功	shǎo lín wǔ dāng gōng	八拍
（8）靈猫捕蝶	líng māo bǔ dié	太極八卦連環掌	tài jí bā guà lián huán zhǎng	八拍
（9）坐馬觀花	zuò mǎ guān huā	中華有神功	zhōng huá yǒu shén gōng	八拍
第二段（快板）每分鐘 104 拍				
（10）野馬分鬃	yě mǎ fèn zōng	臥似一張弓	Wò sì yī zhāng gōng	四拍
（11）雛燕凌空	chú yàn líng kōng	站似一棵松	Zhàn sì yī kē sōng	四拍
（12）黃蜂入洞	huáng fēng rù dòng	不動不搖坐如鐘	Bù dòng bù yáo zuò rú zhōng	四拍
（13）猛虎撲食	měng hǔ pū shí	走路一陣風	zǒu lù yī zhèn fēng	四拍
（14）螳螂捕蟬	táng láng bǔ chán	南拳和北腿	nán quán hé běi tuǐ	四拍
（15）勒馬回頭	lè mǎ huí tóu	少林武當功	shǎo lín wǔ dāng gōng	四拍
（16）鷂子翻身	yào zǐ fān shēn	太極八卦連環掌	tài jí bā guà lián huán zhǎng	四拍
（17）坐馬觀花	zuò mǎ guān huā	中華有神功	zhōng huá yǒu shén gōng	四拍
第三段（念板）				
（18）舉鼎推山	jǔ dǐng tuī shān	棍掃一大片	gùn sǎo yī dà piàn	四拍
（19）神龍回首	shén lóng huí shǒu	槍挑一條綫	qiāng tiāo yī tiáo xiàn	四拍
（20）揮鞭策馬	huī biān cè mǎ	身輕好似雲中燕	qiāng tiāo yī tiáo xiàn	四拍
（21）立馬揚鞭	lì mǎ yáng biān	豪氣衝雲天	háo qì chōng yún tiān	四拍
（22）懷中抱月	huái zhōng bào yuè	外練筋骨皮	wài liàn jīn gǔ pí	四拍
（23）迎風撩衣	yíng fēng liáo yī	內練一口氣	nèi liàn yī kǒu qì	四拍
（24）翻花舞袖	fān huā wǔ xiù	剛柔并濟不低頭	gāng róu bìng jì bú dī tóu	四拍

動作名稱	拍節	曲譜	歌詞
（25）霸王舉旗	四拍		我們心中有天地
（26）抱扇過門			

第四段（快板） 同第二段

動作名稱	曲譜	拍節
（27）野馬分鬃 yě mǎ fèn zōng	臥似一張弓 Wò sì yī zhāng gōng	四拍
（28）雛燕凌空 chú yàn líng kōng	站似一棵松 Zhàn sì yī kē sōng	四拍
（29）黃蜂入洞 huáng fēng rù dòng	不動不搖坐如鐘 Bù dòng bù yáo zuò rú zhōng	四拍
（30）猛虎撲食 měng hǔ pū shí	走路一陣風 zǒu lù yī zhèn fēng	四拍
（31）螳螂捕蟬 táng láng bǔ chán	南拳和北腿 nán quán hé běi tuǐ	四拍
（32）勒馬回頭 lè mǎ huí tóu	少林武當功 shǎo lín wǔ dāng gōng	四拍
（33）鷂子翻身 yào zǐ fān shēn	太極八卦連環掌 tài jí bā guà lián huán zhǎng	四拍
（34）坐馬觀花 zuò mǎ guān huā	中華有神功 zhōng huá yǒu shén gōng	四拍

第五段（念板）

動作名稱	曲譜	拍節
（35）順鸞肘 shùn luán zhǒu	清風劍在手 qīng fēng jiàn zài shǒu	四拍（喊）
（36）裹鞭炮 guǒ biān pào	雙刀就看走 shuāng dāo jiù kàn zǒu	四拍（喊）
（37）前招勢 qián zhāo shì	行家功夫一出手 háng jiā gōng fū yī chū shǒu	四拍
（38）雙震腳 shuāng zhèn jiǎo	就知有沒有 jiù zhī yǒu méi yǒu	四拍（喊）
（39）龍虎相交 lóng hǔ xiàng jiāo	手是兩扇門 jiù zhī yǒu méi yǒu	四拍（喊）
（40）玉女穿梭 yù nǚ chuān suō	腳下一條根 jiǎo xià yī tiáo gēn	四拍（喊）
（41）天女散花 tiān nǚ sàn huā	四方水土養育了 sì fāng shuǐ tǔ yǎng yù le	四拍
（42）霸王揚旗 bà wáng yáng qí	我們中華武術魂 wǒ men zhōng huá wǔ shù hún	四拍（喊）
（43）行步過門 háng bù guò mén		

第六段（慢板） 同第一段

動作名稱	曲譜	拍節
（44）七星手 qī xīng shǒu	東方一條龍 dōng fāng yī tiáo lóng	八拍
（45）攬扎衣 lǎn zhā yī	兒女似英雄 ér nǚ sì yīng xióng	八拍
（46）捋擠勢 lǚ jǐ shì	天高地遠八面風 tiān gāo dì yuǎn bā miàn fēng	八拍
（47）蘇秦背劍 sū qín bèi jiàn	中華有神功 zhōng huá yǒu shén gōng	八拍
（48）摟膝拗步 lǒu xī niù bù	東方一條龍 dōng fāng yī tiáo lóng	八拍
（49）單鞭下勢 dān biān xià shì	兒女似英雄 ér nǚ sì yīng xióng	八拍
（50）挽弓射虎 wǎn gōng shè hǔ	天高地遠八面風 tiān gāo dì yuǎn bā miàn fēng	八拍
（51）白鶴亮翹 bái hè liàng qiào	中華有神功 zhōng huá yǒu shén gōng	八拍
（52）收勢 shōu shì	中華有神功 zhōng huá yǒu shén gōng	八拍

【武術/表演/比賽/專業太極鞋】

正紅色【升級款】
XF001 正紅

打開淘寶天貓
掃碼進店

微信掃一掃
進入小程序購買

藍色【經典款】
XF8008-2 藍

黃色【經典款】
XF8008-2 黃色

紫色【經典款】
XF8008-2 紫色

正紅色【經典款】
XF8008-2 正紅

黑色【經典款】
XF8008-2 黑

綠色【經典款】
XF8008-2 綠

桔紅色【經典款】
XF8008-2 桔紅

粉色【經典款】
XF8008-2 粉

XF2008B（太極圖）白

XF2008B（太極圖）黑

XF2008-2 白

XF2008-3 黑

5634 白

XF2008-2 黑

【太極羊·專業武術鞋】

兒童款·超纖皮

XF808-1 銀

XF808-1 白

XF808-1 紅

XF808-1 金

XF808-1 藍

XF808-1 黑

XF808-1 粉

长袖款

短袖款

微信掃一掃

進入小程序購買

【專業太極服】

多種款式選擇・男女同款

微信掃一掃

進入小程序購買

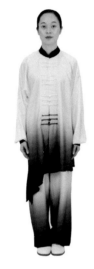

黑白漸變仿綢

淺棕色牛奶絲

白色星光麻

亞麻淺粉中袖

白色星光麻

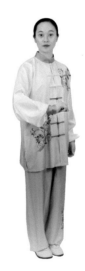

真絲綢藍白漸變

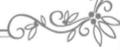

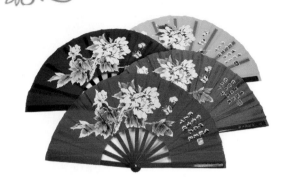

【太極扇】

武術/廣場舞/表演扇

可訂製LOGO

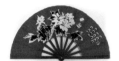

紅色牡丹

粉色牡丹

黃色牡丹

紫色牡丹

黑色牡丹

藍色牡丹

綠色牡丹

黑色龍鳳

紅色武字

黑色武字

紅色龍鳳

金色龍鳳

純紅色

紅色冷字

紅色功夫扇

紅色太極

打開淘寶天貓APP

掃碼進店

微信掃一掃

進入小程序購買

【出版各種書籍】

申請書號>設計排版>印刷出品
>市場推廣
港澳台各大書店銷售

冷先鋒

國際武術大講堂系列教學之一
《太極功夫扇》

書　號：ISBN 978-988-75077-4-1

總 編 輯：冷先鋒

責任印製：冷修寧

翻　译：Philip Reeves（英國） 李 暉 葉志威

版面設計：明栩成

香港先鋒國際集團 審定

太極羊集團　　 赞助

香港國際武術總會有限公司 出版

香港聯合書刊物流有限公司 發行

代理商：台灣白象文化事業有限公司

香港地址：香港九龍彌敦道 525 -543 號寶寧大廈 C 座 412 室

電話：00852-98500233 \91267932

深圳地址：深圳市羅湖區紅嶺中路 2018 號建設集團大廈 B 座 20A

電話：0755-25950376\13352912626

台灣地址：401 台中市東區和平街 228 巷 44 號

電話：04-22208589

印刷：深圳市先鋒印刷有限公司

印次：2021 年 2 月第一次印刷

印數：5000 冊

網站：https:// www.taijixf.com　　https://taijiyanghk.com

Email: lengxianfeng@yahoo.com.hk